Drawing in Color

ANIMALS

Lee Hammond

NORTH LIGHT BOOKS
CINCINNATI, OHIO
www.artistsnetwork.com

About the Author

Polly "Lee" Hammond is an illustrator and art instructor from the Kansas City area. She owns and operates a private art studio named Take It To Art*, where she teaches realistic drawing and painting.

Lee was raised and educated in Lincoln, Nebraska, and established her career in illustration and teaching in Kansas City. Although she has lived all over the country, she will always consider Kansas City home.

Lee has been an author with North Light Books since 1994. She also writes and illustrates articles for other publications, such as *The Artist's Magazine*.

Lee is continuing to develop new art instruction books for North Light and is also expanding her career into illustrating children's books. Fine art and limited edition prints of her work will also soon be offered.

Lee resides in Overland Park, Kansas, along with her family.

Note: You may contact Lee via e-mail at Pollylee@aol.com or visit her Web site at http://LeeHammond.com.

*Take It To Art is a registered trademark for Lee Hammond.

Drawing in Color: Animals. Copyright © 2002 by Polly "Lee" Hammond. Manufactured in China. All rights reserved. No part of this book may be reproduced in any form or by any electronic or mechanical means including information storage and retrieval systems without permission in writing from the publisher, except by a reviewer who may quote brief passages in a review. Published by North Light Books, an imprint of F&W Publications, Inc., 4700 East Galbraith Road, Cincinnati, Ohio 45236. (800) 289-0963. First edition.

Other fine North Light Books are available from your local bookstore, art supply store or direct from the publisher.

06 05 04 03 02 5 4 3 2 1

Library of Congress Cataloging-in-Publication Data
Hammond, Lee 1957-
 Drawing in color: animals / Lee Hammond.
 p. cm.
 Includes index.
 ISBN 1-58180-273-0 (alk. paper)
 [1. Animals in art. 2. Drawing--Technique.] I. Title.

NC780 .H243 2002
743.6--dc21 2001059643

Editor: Bethe Ferguson
Production Coordinator: John Peavler
Cover Designer: Wendy Dunning

METRIC CONVERSION CHART		
to convert	to	multiply by
Inches	Centimeters	2.54
Centimeters	Inches	0.4
Feet	Centimeters	30.5
Centimeters	Feet	0.03
Yards	Meters	0.9
Meters	Yards	1.1
Sq. Inches	Sq. Centimeters	6.45
Sq. Centimeters	Sq. Inches	0.16
Sq. Feet	Sq. Meters	0.09
Sq. Meters	Sq. Feet	10.8
Sq. Yards	Sq. Meters	0.8
Sq. Meters	Sq. Yards	1.2
Pounds	Kilograms	0.45
Kilograms	Pounds	2.2
Ounces	Grams	28.3
Grams	Ounces	0.035

Dedication and Acknowledgements

This book is dedicated to my granddaughter Taylor Marie. I hope you continue to love animals and art as much as I do. Thanks for being such a fun little girl and adding so much joy to my life! I love you!

—Grama Lee

I would also like to dedicate this book to my guardian angel, Penny. Thanks for watching over me and keeping me from harm.

Of all the accomplishments in my life, writing for North Light Books has been one of the most rewarding. My books have opened up an entire world of friendships for me. How lucky we are to live in this day and age, where we have the technology available to communicate across the globe.

I want to thank my readers, wherever you may reside, for supporting my artistic goals. Your warm thoughts and well wishes are gratefully received and appreciated. I wish each and every one of you the very best life has to offer.

A special thank you to everyone at North Light Books for making this dream possible!

Taylor Marie
Age 6

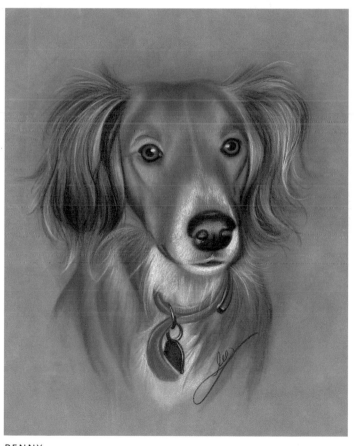

PENNY
Prismacolor pencils on no. 7184 Cinnamon suede board
14" x 11" (36cm x 28cm)

Table of Contents

You Can Do It!

Colored pencil can be a very frustrating and confusing medium. As an art instructor, I see many students struggling in the beginning to learn the various techniques.

As with anything else in life, it just takes some understanding and a lot of practice to become comfortable with something new.

I tell my students to relax when they first begin. Not all artistic attempts need to be wonderful pieces of art which are suitable for framing. Rarely do our first attempts create the results we are striving for. You must not be afraid to experiment.

I've been a professional artist for many years. However, I still struggle

at times and throw away projects that just plain do not work out. It's okay. Struggling and experimenting are part of the process and should not be seen as failures. Experiments are just as important as the final pieces. Learn to embrace them both!

I always remind the beginner that I too was a beginner and was once in their shoes. I honestly didn't like colored pencils when I first began working with them. I was too conditioned as a child to use pencils to just "fill in" color. The process of layering colors, or blending colors, escaped me at first. My projects resembled crayon drawings, and I blamed myself for my lack of talent. However, years

later—when I matured artistically—I figured out my problem. I approached drawing with colored pencil differently and learned to love it.

Unfortunately, back when I was beginning, few books were written on colored pencil. I was forced to learn through trial and error. You now have a wonderful selection of books available by extremely gifted artists. Everything you need to know is at your fingertips. All you really need to do is practice.

Look at the example below. It is the progress of a typical art student. Your progress may appear very similar.

Welcome to the wonderful world of colored pencil!

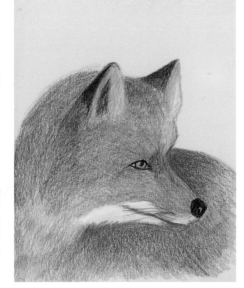

DRAWING BY A STUDENT, LAURA TIEDT
The first attempt is not necessarily a bad drawing. You can see how the student was hesitant about applying the colored pencil. In the end, the drawing looked incomplete.

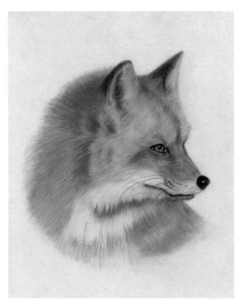

ATTEMPT TWO BY LAURA TIEDT
This second attempt looks much more realistic. The student used layers of color and a heavier application with the pencils, which gave the drawing more depth and realism.

Nothing is more fun for me, as an artist, than turning an ordinary snapshot into a memorable piece of art. I use my camera and my artwork as a way of documenting my life and remembering special things.

Illustration is the art of telling a story through pictures. This drawing takes my snapshot and turns it into something more meaningful. While drawing this piece, I was immediately transported back to that moment in time, remembering everything as I experienced it. Artwork is magical that way. The finished product is more than a drawing, it is a memory.

Note: During the writing of this book my cat, Meowser, unfortunately died due to illness. Now these illustrations are more meaningful to me than ever.

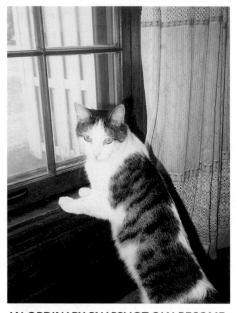

AN ORDINARY SNAPSHOT CAN BECOME INTERESTING ARTWORK

This is a snapshot I took of Meowser. It isn't that good of a picture, but the story behind it is cute. All kitties like to look out the window, and mine is no exception. This time there was a bird outside, and Meowser watched it for quite a while. Of course, as soon as I grabbed the camera he had to look at me instead.

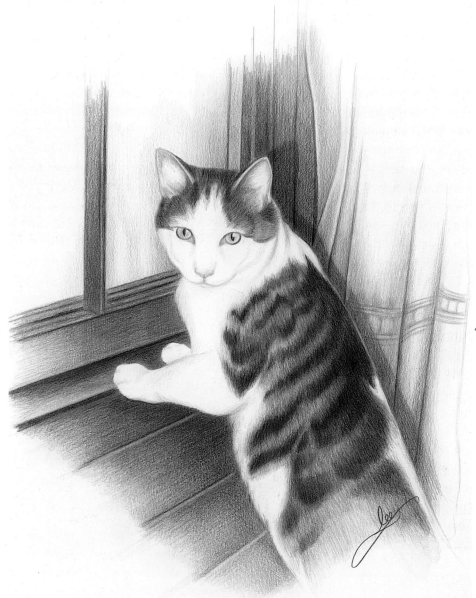

MEOWSER LOOKING OUT THE WINDOW
Verithin pencils on no. 2259 Antique White mat board
12" x 9" (31cm × 23cm)

Getting Started

Using the Proper Pencils

Each brand of colored pencil has a different appearance when used. Each pencil is made differently to create an unique effect. I can't easily answer which pencil is "the best," or which one I like the most. It really depends on the final outcome and the "look" I want my work to have. Rarely will I use just one brand of pencil to complete a project. Any one of them alone is somewhat limited. I have found that by using a combination of pencils, I can create more variety in my techniques. This enables me to achieve the look I'm trying to accomplish. The following is an overview of the four types of pencils I like the most.

PRISMACOLOR PENCILS

Prismacolors have a thick, soft wax-based lead that provides a heavy application of color. They are opaque and will completely cover the paper surface. They are excellent for achieving smooth, shiny surfaces and brilliant colors. The colors can be easily blended to produce an almost "painted" appearance to your work. They come in a huge selection of colors: 120 or more.

VERITHIN PENCILS

Verithins also have wax-based lead, but have a harder, thinner lead than Prismacolors. Because of their less waxy consistency, they can be sharp-ened to a very fine point. They are compatible with Prismacolor but are more limited in their color range, which is thirty-six. I use Verithins whenever I want the paper to show through because they cannot build up to a heavy coverage. They can give you very sharp, crisp lines. Verithins are good for layering colors without the colors mixing together. Prismacolors can give your work a painted appearance; Verithins give your work more of a "drawn" look.

Prismacolor pencils

Verithin pencils

STUDIO PENCILS

Studio pencils, by Derwent, are somewhat like a composite of the other brands. They are a clay-based pencil with a range of seventy-two colors. Applied heavily, they can create deep, dark hues. Applied lightly, they can be blended with a tortillion (see page 10). They also have a sister pencil called the Artists line, which is the same formulation with a bigger lead diameter. I use the Studio line because I prefer a sharper point. Also, because it is clay based, it will not build up color as well as Prismacolor and will give more of a matte (nonglossy) finish.

NEGRO PENCILS

Using the Negro clay-based black pencil is an excellent way to achieve deep, rich black in your work without a hazy wax buildup. This is the blackest pigment I've ever found in a colored pencil. It comes in five degrees of hardness, ranging from soft (1) to hard (5).

Studio pencils.

Negro pencils.

Tools of the Trade

As with anything we do, the quality of our colored pencil artwork is determined by the quality of the tools we employ for the job. The following is a list of supplies you will need to succeed.

PAPER

The paper you use with colored pencils is critical to your success. There are many fine papers on the market today. You have hundreds of options of sizes, colors and textures. As you try various types, you will undoubtedly develop your personal favorites.

Before I will even try a paper for colored pencil, I always check the weight. Although there are many beautiful papers available, I feel many of them are just too thin to work with. I learned this the hard way, after doing a beautiful drawing of my daughter only to have the paper buckle when I picked it up. The crease formed was permanent, and no amount of framing kept my eye from focusing on it first. From that point on, I never used a paper that could easily bend when picked up. The more rigid, the better! Strathmore has many papers that I often use. The following is a list of

Prismacolor pencils on mat board.

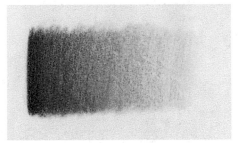

Prismacolor pencils on suede board.

Strathmore Renewal paper has soft colors with the look of tiny fibers in it. Artagain, also by Strathmore, has a speckled appearance and deeper colors. Both have a smooth surface.

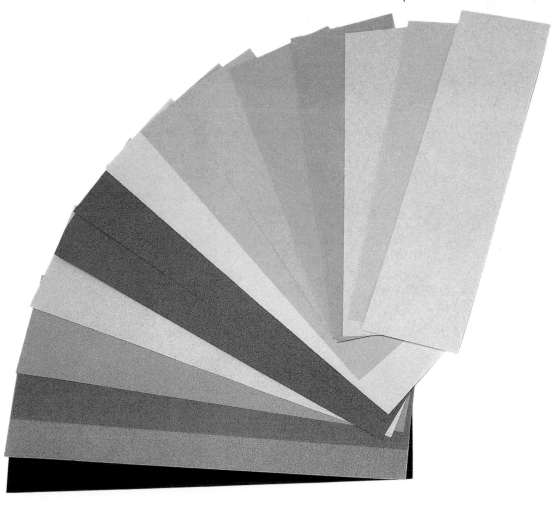

the ones I personally like to use the most and recommend to my students.

Artagain—Artagain is a recycled paper by Strathmore that has somewhat of a flannel appearance to it. This 60-lb. (130gsm) cover-weight paper comes in a good variety of colors. Although it has a speckled appearance, its surface has no noticeable texture. It is available in both pads and single sheets for larger projects.

Renewal—Renewal is another Strathmore paper, very similar to Artagain, but it has the look of fibers in it instead of speckles. I like it for its soft earth tones.

Crescent Mat Board—My personal favorite is Crescent because of the firmness of the board. It is already rigid and doesn't have to be taped down to a drawing board. This makes it very easy to transport in a portfolio. Its wide range of colors and textures is extremely attractive. Not only do I match the color to the subject I am drawing, I will often use the same color of mat board when framing the piece to make it color coordinated.

Crescent Suede Board—Crescent Suede Board is another one of my favorites.

It has a surface like suede or velveteen. I have developed a technique using Prismacolor that makes it look like pastel when applied to this fuzzy surface.

PENCIL SHARPENERS

Pencil sharpeners are very important with colored pencils. Later in the book, you will see how many of the techniques require a very sharp point at all times. I prefer an electric sharpener, or a battery-operated one when traveling. A handheld sharpener requires a twisting motion of the arm. This is usually what breaks off the pencil points. The motor-driven sharpeners allow you to insert the pencil straight on, reducing breakage. If you still prefer a handheld sharpener, spend the extra money for a good metal one, with replacement blades.

ERASERS

I suggest that you have three different erasers to use with colored pencil: a kneaded eraser, a Pink Pearl eraser and a typewriter eraser. Although colored pencil is very difficult, if not impossible, the erasers can be used to soften colors as you draw.

The kneaded eraser is like a squishy piece of rubber, good for removing your initial line drawing as you

work. Because of its soft, pliable feel, it will not damage or rough up your paper surface.

The Pink Pearl eraser is a good eraser for general cleaning. I use it the most when I am cleaning large areas, such as backgrounds. It is also fairly easy on the paper surface.

The typewriter eraser looks like a pencil with a little brush on the end of it. It is a highly abrasive eraser, good for removing stubborn marks from the paper. It can also be used to get into tight places or to create clean edges. However, great care must be taken when using this eraser, because it can easily damage the paper and leave a hole.

MECHANICAL PENCIL

I always use a mechanical pencil for my initial line drawing. Because the lines are so light, unlike ordinary drawing pencils, they are easily removed with the kneaded eraser. As you work, replace the graphite lines with color.

TORTILLIONS

Tortillions are cones of spiral-wound paper. They are used to blend after you have applied the colored pencil to the paper. I use them only with Studio pencils. Prismacolor is much

too waxy for this technique. Verithins work somewhat but don't blend as evenly as the clay-based pencils.

ACETATE GRAPHS
Acetate graphs are overlays to place over your photo reference. They have grid patterns on them that divide your picture into even increments, making it easier to draw accurately. I use them in both 1-inch (3cm) and ½-inch (1cm) divisions. They can be easily made by using a permanent marker on a report cover. You can also draw one on paper and have it copied to a transparency on a copy machine.

TEMPLATES
Templates are stencils that are used to obtain perfect circles in your drawing. I always use one when drawing eyes to get the pupils and irises accurate.

MAGAZINES
The best source for drawing material is magazines. I tear out pictures of every subject and categorize them into different bins for easy reference. When you are learning to draw, magazines can provide a wealth of subject matter. When drawing people, there is nothing better than glamour magazines.

CRAFT KNIVES
Craft knives are not just for cutting things; they can actually be used as drawing tools. When using Prismacolor, I use the edge of the knife to gently scrape away color to create texture such as hair or fur. A knife can also be used to remove unwanted specks that may appear in your work. As you can probably imagine, it is important to take care with this approach to avoid damaging the paper surface.

FIXATIVES
The type of spray that you use to fix your drawing depends again on the look you want your piece to ultimately have. I use two different types of finishing sprays, each one with its own characteristics.

Workable fixative—The most common of the sprays, the workable fixative is undetectable when applied. The term "workable" means that you can continue drawing after you have applied the spray. Experience has taught me that this is more true for graphite and charcoal than it is for colored pencil. I have found fixative to actually behave as a resist. I use it whenever I don't want the appearance of my work to change. When using

Prismacolor, the wax of the pencil will rise to the surface, making the colors appear cloudy and dull. Workable fixative will stop this "blooming" effect and make the colors true again.

Damar varnish—I use this spray when I want a high-gloss shine applied to my Prismacolor drawings. It will give the drawing the look of an oil painting and make the colors seem shiny and vivid. (Its primary use is to seal oil paintings.) I will often use this when drawing fruit and flowers, but it will also make a portrait beautiful.

HORSE HAIR DRAFTING BRUSH
This is an essential tool when you are drawing, but even more so when using colored pencil. Colored pencil, particularly Prismacolor, will leave specks of debris as you work. Left on the paper, they can create nasty smudges that are hard to erase later. Brushing them with your hand can make it worse, and blowing them off will create moisture on your paper, which will leave spots. A drafting brush gently cleans your work area without smudging your art.

> NOTE—
> When a fixative is used on colored pencils that have been blended with a tortillion, the pigment can seem to melt into a watercolor appearance. The colors will appear much brighter and darker. Leave unsprayed.

The Different "Looks" of Colored Pencil

Drawing in colored pencil is a some what deceptive term because there are many types of colored pencils, each with their own formulation. Each brand of pencil has its own unique look, produces a different effect and requires a different technique. When deciding which pencil to use, you must decide which look you want your artwork to have.

When you begin a new project, you must first decide upon the look you would like to achieve, then find the pencil that will create that look. Each of these drawings has its own look. Some are bold and bright, others soft and delicate.

Because of the different colors and textures found in the varying species of animals, there is not one pencil that can always give you what you need. You will require a variety of pencils, and use many methods, to

COLORS USED

Squirrel: White, French Grey 20%, Light Umber, Dark Umber, Bronze, Sepia (fur) Salmon Pink (ears) Tuscan Red and Black (eye).
Background: Limepeel, Apple Green, Bronze, Light Umber, Yellow Ochre, Deco Yellow and White.
Tree Bark: Dark Umber, Light Umber, French Grey 20%, Deco Yellow, Black and White.

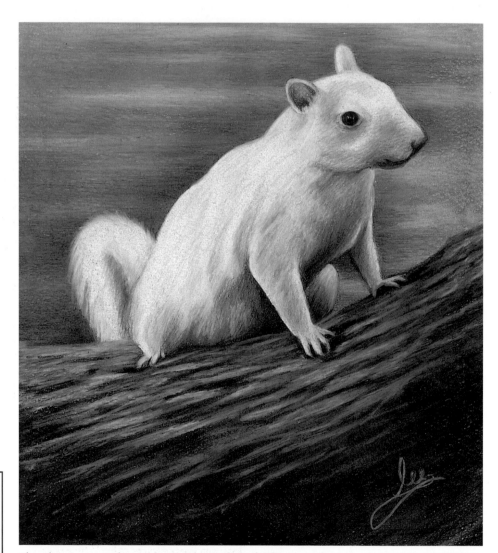

This drawing was done on smooth mat board. The smooth surface allows you to apply firm pressure to the pencil, completely covering the paper surface. This is called *burnishing*. That is how I made the white fur fill in and the tree bark to appear textured. Because of the opaque nature of these pencils, you can draw on dark-colored papers. This board was a medium gray color, and the white showed up beautifully. Whenever I need to apply heavy layers of color, or build up extreme texture, I use Prismacolor. *Note: This drawing was sprayed with workable fixative when completed, to prevent wax bloom.*

WHITE SQUIRREL
Prismacolor pencils
on no. 3308 Oxford
mat board
10" x 8" (25cm x 20cm)

capture all of the different animals seen in nature.

Each of these drawings has a distinct look, and all were done with a different brand of pencil. Before I begin a piece, I have to analyze the characteristics of my subject and decide which pencil creates the look I desire.

PRISMACOLOR PENCILS

Prismacolor pencils have a heavy wax content and deep pigments, and therefore go on very concentrated and opaque. Prismacolor pencils are known for their thick leads and rich colors.

VERITHIN PENCILS

Verithin are good pencils to use when drawing animals. They are made by the same manufacturer as Prismacolor but have a thinner lead, which produces fine, thin lines. They also have less wax and go on a little "drier" than Prismacolor.

Verithin pencils also work well on dark paper. This rabbit was drawn on a medium gray board, and the white pencil shows up beautifully.

Verithin pencils do not burnish like Prismacolor. Instead, the colors "layer" without blending together. The result is a highly textured appearance.

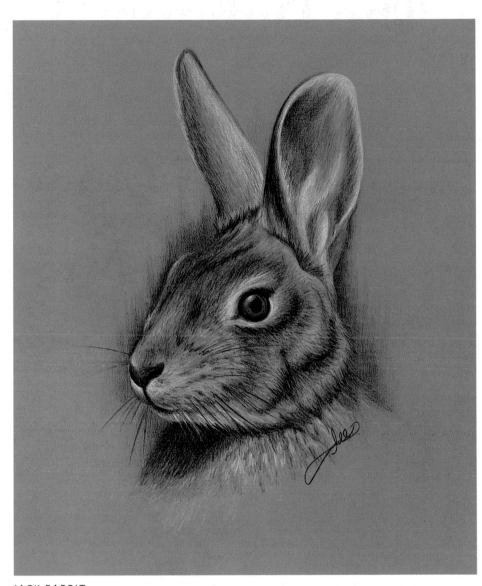

JACK RABBIT
Verithin pencils on no. 3331 Sage mat board
14" x 11" (36cm x 28cm)

Study the drawing of the rabbit closely, and you can see different layers of colors. They were applied with short, quick strokes and look just like the layers of fur. Whenever I need to replicate coarse hair or layered fur, I use Verithin pencils.

COLORS USED

Rabbit: Black, Dark Brown, Terra Cotta and White.
Background: Dark Green and Black.

STUDIO PENCILS

Studio pencils are manufactured by Derwent. They are clay-based pencils as opposed to the wax-based pencils we looked at previously. Because of their formulation, these pencils have the advantage of being easily blended with a stump or tortillion (see page 10). The result is a smooth, subtle blending of tone.

Another advantage to using these pencils is that you can use them heavily and achieve dark color and deep tones. Because they are not wax-based, however, you will not get the same effects when burnishing as you would with Prismacolor.

COLORS USED

Puppy: Chocolate Brown, Ivory Black, Terra Cotta, Burnt Yellow Ochre, Venetian Red and Copper Beech.
Drinking Glass: Ivory Black, Venetian Red, Turquoise Blue and Cedar Green.
Background: Cedar Green, Chocolate Brown, Olive Green and Ivory Black.
Foreground: Ivory Black, Chocolate Brown and Turquoise Blue.

NOTE —

The colors of the puppy and the background are all reflecting into the glass. Since glass and water are clear, they are drawn using the surrounding colors that bounce off of the shiny surfaces.

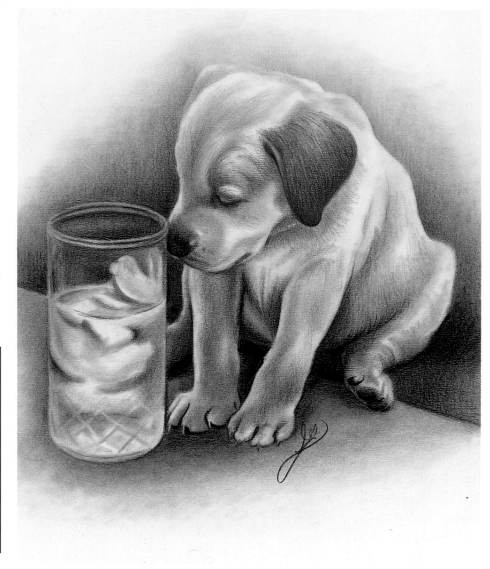

KIMBER AND THE DRINKING GLASS
Studio pencils on no. 912 India mat board
16" x 12" (41cm x 30cm)

Sometimes a subject will have a combination of textures to capture, and they will require a special application of the pencils to create. To render this drawing, I used a combination of techniques. I first placed in the colors of the puppy and blended the colors smooth with a tortillion—this creates the contours and form of the body. I then placed more color on top of the blended tones to create the texture of the fur. I used this technique for the entire drawing. Look at all the areas of the piece and you can see where I used both blending and pencil lines for realism.

Technique

LAYERING

To best teach layering I like to start my students out with Verithin pencils. This technique also carries over to the other brands as well. Once you learn how to layer colors well with these pencils, using the other brands will be easy.

Layering is the process of using a very sharp pencil point and applying the tone gradually and evenly. Do not let the pencil point become dull. This alters the width of the lead and makes the drawing look crayon-like.

A colored pencil has a "feel" to it. When drawing darker areas, I have a tendency to hold my pencil closer to the tip allowing me to use more pressure without breaking the lead. As I move to lighter areas I pull back, holding the pencil further back from the tip. This helps me touch the paper surface lightly, giving it a softer appearance.

You should blend your tone very gradually as they fade from dark to light. There should be no choppiness between tones, no definite line where one tone ends and another begins. Practice first with value scales. The more you do, the more proficient you will become. Start with just black pencil at first, layering from dark to light by altering the pressure you apply to the pencil. Let the tone fade into the color of the paper.

It is important when you apply the pencil that your lines are very close together so they fill in any white space. Going back and forth slowly helps you do this.

BURNISHING

Once you are comfortable with the layered approach, try Prismacolor pencils. You will see how different the pencils are.

Begin with three colors of pencils: Black, White and Cool Grey 50%. This process will begin the same as layering, but you will continue to build up the color until it completely covers the paper surface. This is where you will use burnishing, a technique in which you use a lighter color to blend the darker colors into one another.

For example, start the value scale with the Black and then apply the Cool Grey 50% next to and overlapping the Black. The lighter color (Cool Grey 50%) going into the darker one (Black) will soften the two colors together. Next, add White into and overlapping the Cool Grey 50%. Continue burnishing the

DON'T! This type of pencil application makes your work look like scribbled crayons.

A value scale drawn correctly with Verithin pencils. The tones fade gradually without visible pencil lines. This is called *layering*.

A value scale drawn with Prismacolor pencils. This is called *burnishing*.

A value scale drawn with Studio pencils. This is called *blending*.

colors, alternating the addition of light and dark, until they blend together for a smooth, gradual look. This technique resembles a "painted" appearance.

Prismacolor drawing is the process of applying many colors, each one into the others, always using a lighter color to burnish. Sometimes you have to layer and burnish many times to get the look you want. This technique requires a lot of patience, but the nice thing about it is that it's best done with a dull pencil point.

BLENDING

Blending is the application of clay-based pencils that are smoothed out with the aid of a tortillion or stump. The tones appear very smooth and gradual. There appears to be no visible pencil lines, and the tones fade into one another, transitioning smoothly.

The following value scales show how each pencil appears when applied, revealing different, distinct personalities. Is one method better than another? No! I recommend learning them all.

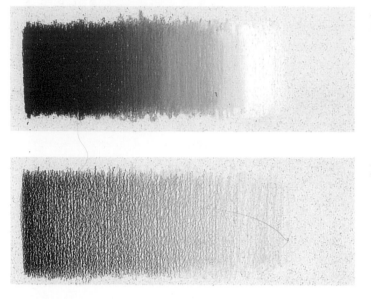

A value scale in Prismacolor pencils (burnished).

A value scale in Verithin pencils (layered).

A value scale in Derwent Studio pencils (blended).

Basic Shapes and Shading

Because it is important to fully understand what it takes to create depth and realism in your work, I begin all of my books with the same information: the five elements of shading and practice exercises of the sphere. The five elements of shading can be found in every three-dimensional shape. The five elements of shading are as follows (listed in order from darkest to lightest):

1. **Cast shadow.** This is the darkest part of your drawing. It is underneath the sphere, where no light can reach. It gradually gets lighter as it moves away from the sphere.
2. **Shadow edge.** This is where the sphere curves and the rounded surface moves away from the light. It is not the edge of the sphere, but is inside, parallel to the edge.

3. **Halftone area.** This is the true color of the sphere, unaffected by either shadows or strong light. It is found between the shadow edge and the full light area.
4. **Reflected light.** This is the light edge seen along the rim of the sphere. This is the most important element to include in your drawing to illustrate the roundness of the surface.
5. **Full light.** This is where the light is hitting the sphere at its strongest point.

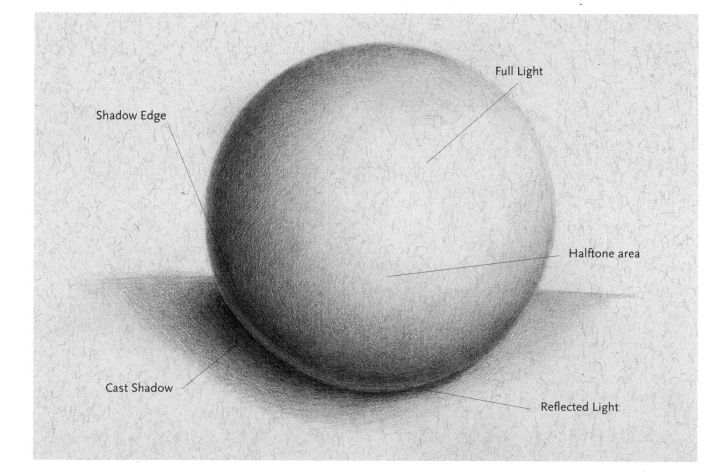

Full Light

Shadow Edge

Halftone area

Cast Shadow

Reflected Light

Basic Shapes

The following are all of the basic shapes that can be seen when drawing animals. Each one has had the five elements of shading applied, giving them the illusion of form and realism. Each of these shapes should be drawn and practiced over and over, until the process becomes second nature to you.

As you analyze these shapes, try to think of where each of them would be found in the shapes of animals and their surroundings. Think of other subject matter as well, and you will see the importance of including these forms in your artwork.

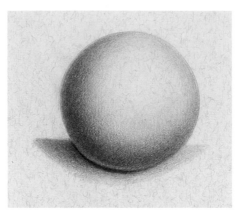

THE SPHERE
Look for the five elements of shading here.

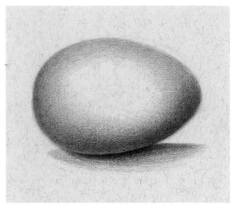

THE EGG
This can be seen in the shape of an animal's head, and also in the body.

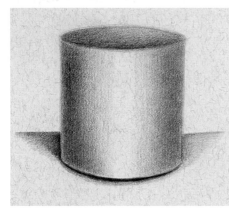

THE CYLINDER
This shape can be seen in the neck area of an animal, and also in the trunks of trees.

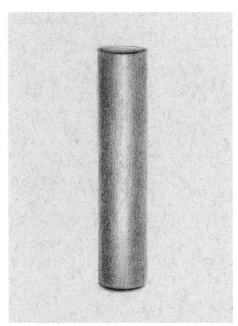

THE LONG CYLINDER
This can be found in the legs of an animal. It also can be found in the necks of long-necked animals, such as giraffes. The small limbs and branches of a tree will also be made up of this shape.

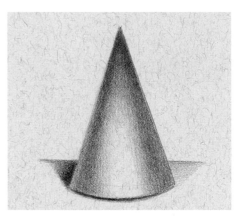

THE CONE
This can be seen in the shape of a bird's beak.

Drawing a Sphere Step-by-Step

Using this step-by-step example, practice drawing the sphere. I have used Verithin pencils for this exercise. After drawing the sphere, practice drawing the egg also. Apply the five elements of shading as well. The more of this you do now, the better your drawings will be later.



COLORS USED

Dark Brown, Poppy Red and Canary Yellow.



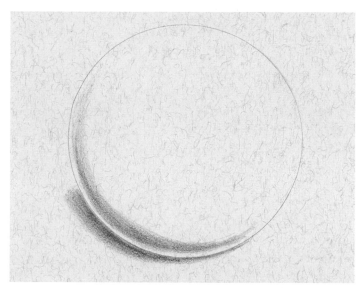

1 Trace around a circular object, or use a template to give yourself a round outline. With Dark Brown, add the cast shadow below the sphere. Also add the shadow edge. Remember, this does not go to the edge of the sphere, but is inside, parallel to the edge. The space between will become the reflected light area.

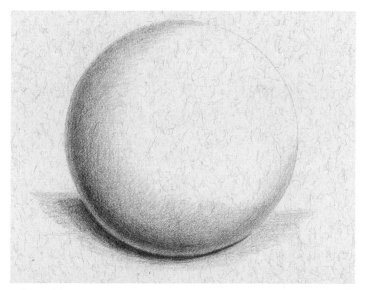

2 Add Poppy Red, overlapping the Dark Brown that is already there. You are now creating the halftone area. Work up gradually to the light area. Place some Poppy Red below the sphere, over the cast shadow and around to the other side. This gives you the illusion of a tabletop.

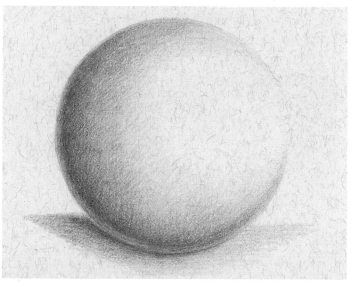

3 With Canary Yellow, lightly overlap all of the colors already there. Lighten your touch and gradually fade into the color of the paper in the full light area.

Drawing an Egg Step-by-Step

For additional practice, use this example of a step-by-step egg. It has been drawn with Studio pencils and blended with a tortillion. It has a smoother look to it than the sphere exercise before, doesn't it?

COLORS USED
Chocolate Brown

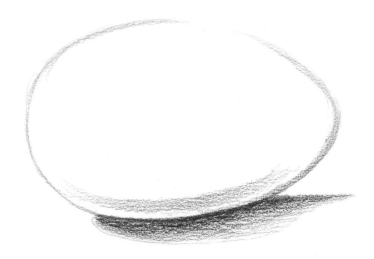

1 Lightly sketch an outline of an egg with your mechanical pencil. Go over it lightly with Chocolate Brown. Place the cast shadow below the egg. Lightly apply the shadow edge, leaving room for the reflected light. The light is coming from the front on this example, so the shadow areas are off to the sides.

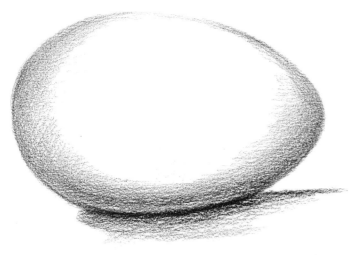

2 Build your tone with the Chocolate Brown until it looks like mine. This area is the halftone. Lighten your touch as you move toward the full light area.

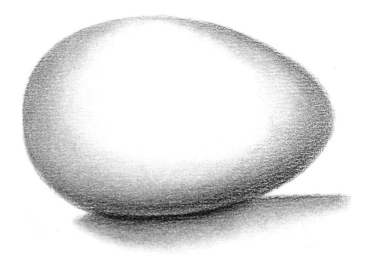

3 With a tortillion, smooth the tones. Begin in the dark areas and work toward the lighter ones, lightening your touch as you go. Can you see how the color changes when blended? It takes on a warmer appearance.

The Cylinder

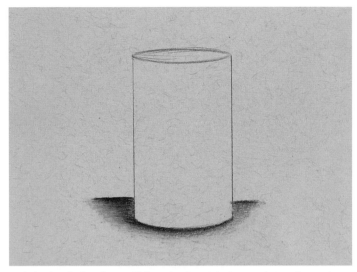

Lightly sketch the shape of the cylinder with the mechanical pencil. Apply the cast shadow with Dark Brown. Soften the edge as it comes away from the cylinder with Light Umber and then Beige. Use the lighter colors to soften the tones together.

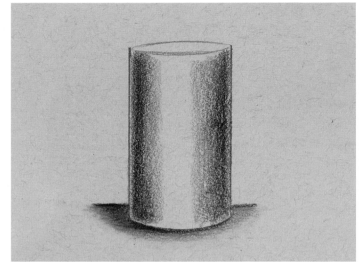

Apply the shadow edge with Dark Brown. Lighten your touch as you move to the halftone area. Overlap the Dark Brown with Light Umber. Use the lighter color to blend the two together. Lighten your touch as you fade into the full light area.

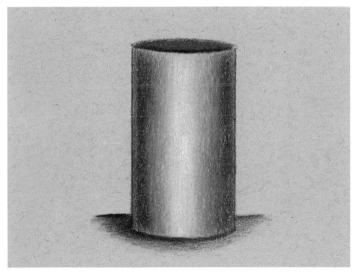

With Beige and White, create the full light area. Blend the Beige into the Light Umber you used previously. Blend White into the Beige or the full light.

COLORS USED

Dark Brown, Light Umber, Beige and White.

Animal Basic Shapes

These line drawings show how the overall form of an animal can be broken down into basic shapes. Some shapes appear very round, while others have definite angles to them. Angles are very important to the realistic depiction of shapes.

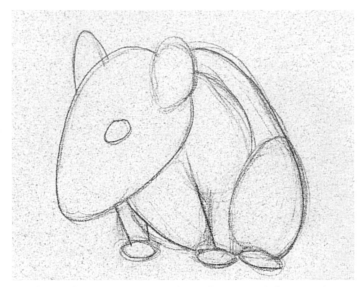

The figure of a mouse, as seen in basic shapes. Look for areas that are rounded and those that have angles to them.

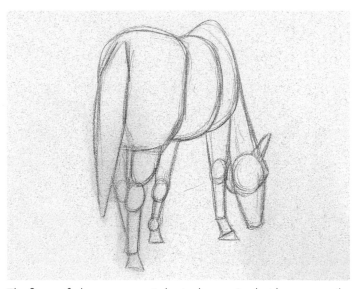

The figure of a horse, as seen in basic shapes. Look at how square the rump area appears.

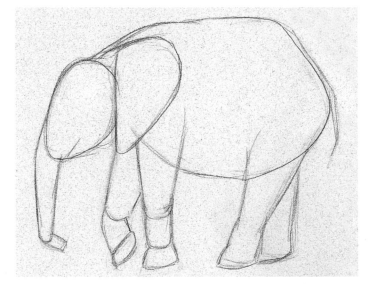

The figure of an elephant, as seen in basic shapes. The body is very egg-shaped. The heavy legs are like cylinders.

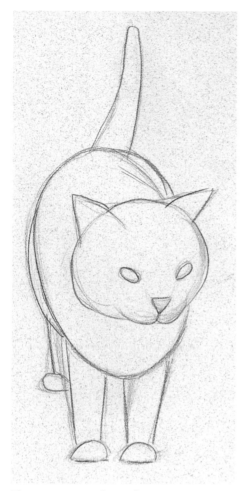

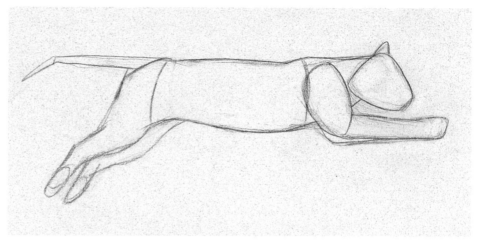

The running cat looks like a long cylinder.

The cat as seen in basic shapes.

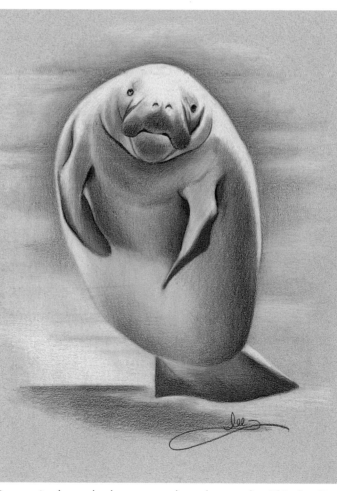

Some animals are clearly more one shape than another. This drawing of a manatee shows how important the egg shape is. This drawing was done with Studio pencils.

Graphing

In order to apply the principles of shapes and tone that you learned from the previous chapter, you must first have an accurate foundation to build on. It is essential to have your shapes precise before you begin the rendering phase, as it is very difficult to change or alter the shape once a certain amount of tone is in place.

This puzzle exercise may seem a bit juvenile at first, but in reality it is an excellent exercise to practice drawing shapes.

When drawing, everything you look at should be viewed as a collection of interlocking shapes. One shape will lead to another. Try to not see the subject for what it *is*, but more for what it *looks* like.

Doing this puzzle exercise will reinforce the fact that you can draw accurately. It is easy to draw shapes when they don't look like anything recognizable.

None of the shapes in these boxes resemble anything, so you will have no problem drawing them. It is only when we recognize something that it becomes difficult, because we will draw from memory instead of observation.

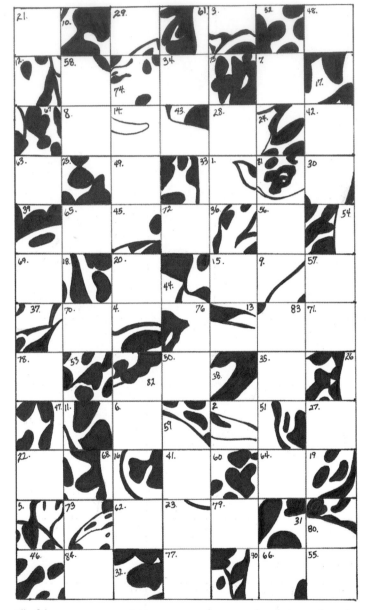

All of these squares contain nonsense shapes and each is numbered. Place the shape in the appropriate box on the following page.

Practice Page

1.	2.	3.	4.	5.	6.	7.
8.	9.	10.	11.	12.	13.	14.
15.	16.	17.	18.	19.	20.	21.
22.	23.	24.	25.	26.	27.	28.
29.	30.	31.	32.	33.	34.	35.
36.	37.	38.	39.	40.	41.	42.
43.	44.	45.	46.	47.	48.	49.
50.	51.	52.	53.	54.	55.	56.
57.	58.	59.	60.	61.	62.	63.
64.	65.	66.	67.	68.	69.	70.
71.	72.	73.	74.	75.	76.	77.
78.	79.	80.	81.	82.	83.	84.

NOTE —
Do not try to figure out what you are drawing while doing this exercise. Concentrate on just shapes!

You can copy this page if you do not want to draw in your book. Be sure all of the shapes are drawn in accurately. When you are finished, turn it upside down.

Drawing From Graphed Photos—Grizzly Bear

You can break down anything you see into the same type of puzzle shapes by placing an acetate grid over your photograph. You can also have the photo copied and draw your grid on that. Let the following pages guide you, and you will produce some of the most accurate drawings you've ever done.

Study the photo of the grizzly bear. Can you see how the grid placed over it has reduced it into manageable shapes? The line drawing was done by re-creating what I saw in each box, one box at a time. All the shapes connected together to create the form of the bear. I started by first drawing a very light grid on my mat board with a mechanical pencil. Since this grid would need to be erased later, I was careful to not press hard when I drew.

I used 1-inch (3cm) squares to help me compose this bear. You can enlarge a drawing by making your boxes larger on your paper than the ones on your photograph. As long as you are working with perfect squares, it is all relative. You can also reduce the size by making your grid smaller in scale than the photo.

Draw this bear on a piece of light-colored mat board. I chose a golden color called India. Save this line drawing for a project you will do with Verithin pencils on page 55.

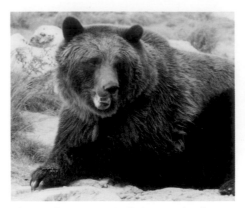

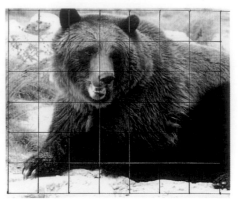

Photo reference. You will also use this for a later project.

A copy of the photograph with a 1-inch (3cm) grid applied.

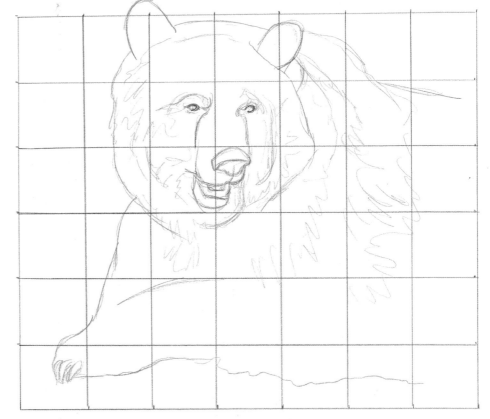

Lightly draw a grid of 1-inch (3cm) squares on a piece of light-colored mat board (I used no. 912 India mat board). Use the same amount of squares as on the graphed photo.

Draw the shapes you see in each box, one box at a time, treating them as you did the shapes with the puzzle exercise on the previous page. This will be used for a project on page 55.

Dalmation

Using a medium-gray piece of mat board, re-create this photograph of the dalmatian. It will be used later in the book for a project using Prismacolor pencils.

Photo reference. You will also use this for a later project on page 59.

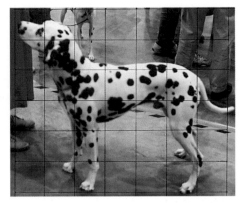

A copy of the photograph with a 1-inch (3cm) grid applied.

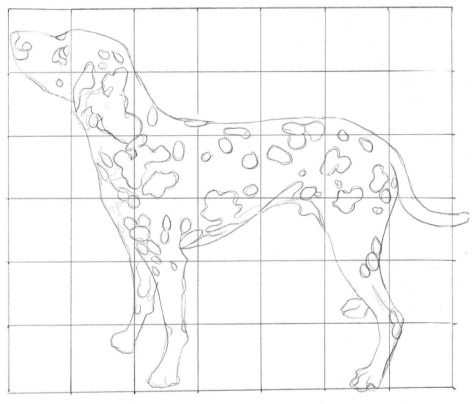

Lightly draw a grid of 1-inch (3cm) squares on a piece of medium-gray mat board (I used no. 3331 Sage mat board). Use the same amount of squares as on the graphed photo. This will be used for a project on page 59.

NOTE —
This drawing is complex due to all of the dog's spots, so go slowly. Draw for accuracy, not speed.

Puppy

Draw this photograph of the puppy on a piece of plain bond paper. It will be used for a project on page 72, using suede board. Since erasing is impossible on suede board, we will have to transfer this line drawing to it using a different method.

It may seem like a lot of work, but it is worth it to draw on this paper. The effects you achieve are well worth the effort!

Photo reference. You will also use this for a later project.

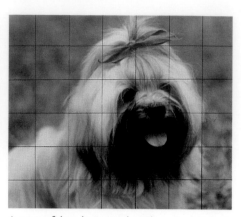

A copy of the photograph with a 1-inch (3cm) grid applied.

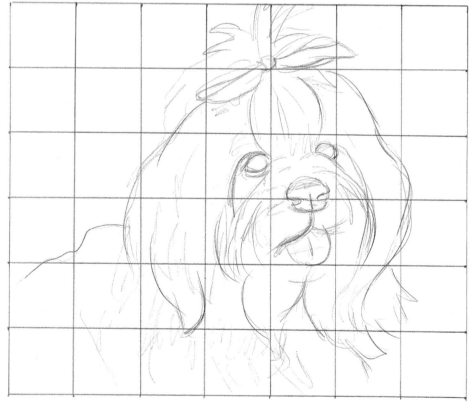

Lightly draw a grid of 1-inch (3cm) squares on a piece of light-colored mat board. You can use a piece of copy paper, because it will be transferred later to a piece of suede board. Use the same amount of squares as on the graphed photo. This will be used for a project on page 72.

Squirrel

This photograph and line drawing will be used for a project using Studio pencils. This exercise can be found on page 64. For this drawing I used a gray mat board.

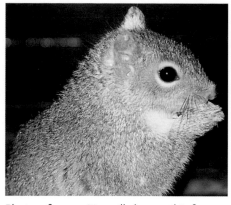

Photo reference. You will also use this for a later project.

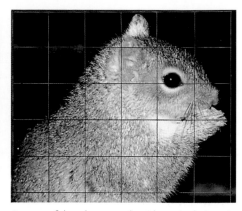

A copy of the photograph with a 1-inch (3cm) grid applied.

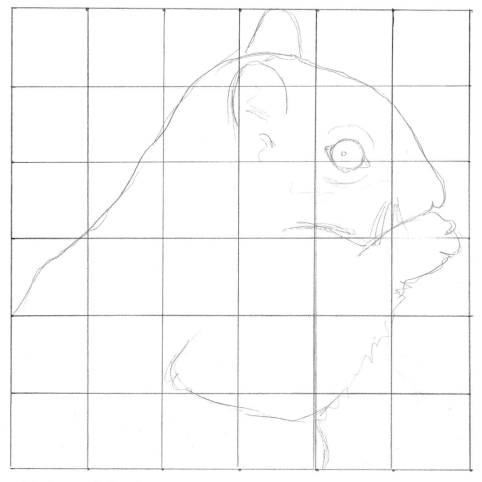

Lightly draw a grid of 1-inch (3cm) squares on a piece of light-colored mat board (I used no. 3331 Sage mat board). Use the same amount of squares as on the graphed photo. This will be used for a project on page 64.

Drawing Animal Features in Prismacolor

Drawing animals requires the same attention to detail as drawing portraits of people. Animals have distinct qualities and personalities that must be present in your drawing to make them appear believable and realistic.

I start my students off with the same advice as if I were teaching them portraiture. Practice! Practice! Practice! And begin with the basic features. The more you do, the more fully you will understand the anatomy and its shapes. Let's begin with the eyes.

I always start my drawing with the eyes of my subject. For me, that is where all the personality is. It is where the life of my subject appears, and the soul of that life is revealed.

Although human eyes carry many of the same characteristics from person to person, animals all have very distinct traits attributed to their species.

Look at the shiny nature of eyes. When drawing them, be sure to place a "catchlight" in the eyes. This is a reflection. It should be placed in the eye so it is half in the pupil and half in the iris. If your photo reference shows more than one, eliminate one of them. If it shows it covering the pupil, change it.

Not only does the shape of the eye differ between the species, but so does the shape of the pupil. The round iris we are familiar with in our own eyes is not always present when looking at animals. Some species have elongated pupils. The pupil of a cat varies due to the light, and can appear as a mere vertical slit to a round circle.

Some reptiles also have a vertical slit for an iris; sometimes it appears vertical and other times it appears horizontal. These are important features that are distinct to that particular species.

Horses or deer have irises that are wide and oval and appear more horizontal. They also have eyelashes that must be captured when drawing them.

The eyes of many monkeys resemble those of humans. However, the sclera, or white part of the human eye, appears brown in monkeys. Rarely will you see the white area of the eye when observing animals.

On eyes like those of squirrels and some other rodents, the pupil and iris are not easy to see. The eye looks almost entirely black.

Whatever species you are drawing, it is always important to accurately capture the shapes first before adding the color. Also, place the iris and pupil in the eye right away to be sure you have them looking in the right direction before continuing on with your drawing.

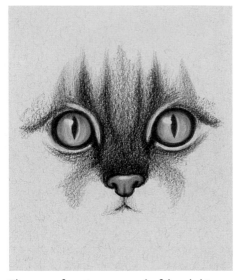

The eyes of a cat are very colorful and shiny. Prismacolor pencils capture these qualities the best.

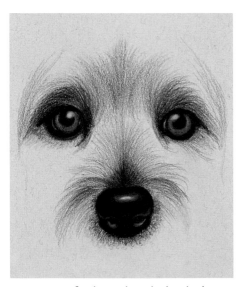

Puppy eyes of a shaggy breed. The shadows around the eyes make them look deep set.

Eyes

Notice the catchlight in all of these examples. I have placed it half in the pupil and half in the iris.

All of these eyes illustrate distinct characteristics seen in specific species. To enhance the appearace of the eyes, I used both a layered and burnished approach for all of them.

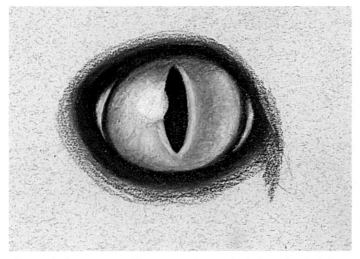

The pupil of a cat's eye will vary according to the light. In bright light, the pupil appears as a vertical slit.

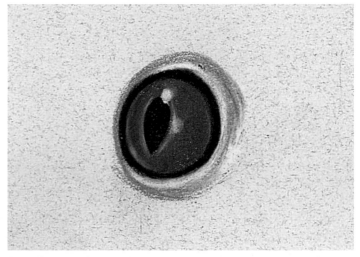

A tree frog's eye has very bright colors; it also has a vertical slit for a pupil.

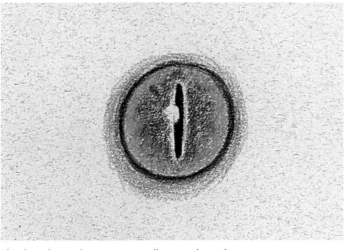

This lizard's eye has a very small, vertical pupil.

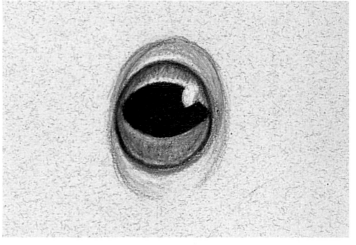

This frog's eye has a horizontal shape to the pupil.

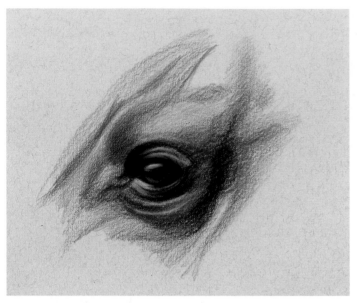

The eye of a horse has a horizontal shape to the pupil. Because of the dark color of the eye, it is sometimes hard to see.

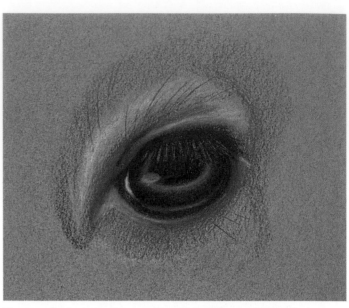

The eye of a deer closely resembles that of a horse. Notice the long eyelashes.

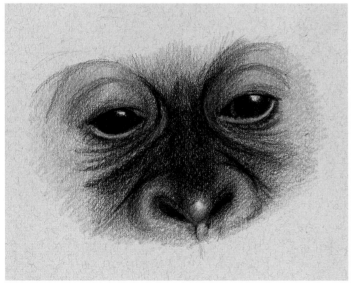

The eyes of a gorilla and a human are similar in shape, but the sclera of the eye is white in humans and brown in primates.

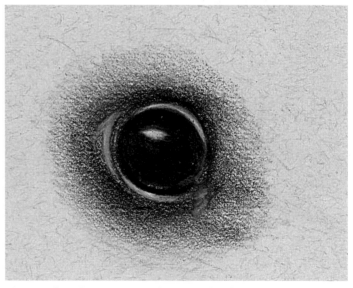

The eye of a rodent, as seen in this example of a squirrel, is very black. It is hard to see where the pupil and iris separate.

Noses and Mouths

Noses and mouths of animals will also vary from species to species. Because of the different needs and living conditions each animal has, their noses and mouths are designed to aid in their existence. For instance, the soft nose and mouth of a vegetarian bunny do not have the same requirements and characteristics found in a meat-eating tiger.

Study the various noses and mouths presented here. Ask yourself what importance the shapes have to that particular animal. Is it an animal that uses its ability to smell to exist, thus having larger nostrils?

Does it have large teeth to hunt and kill its prey? All of these things are important to you as an artist, to truly "see" your subject matter.

In the animal kingdom, the nose and mouth are closely connected, so I generally have my students practice drawing them together.

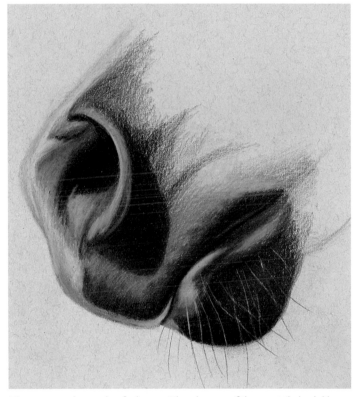

The nose and mouth of a horse. The shapes of the nostrils look like teardrops.

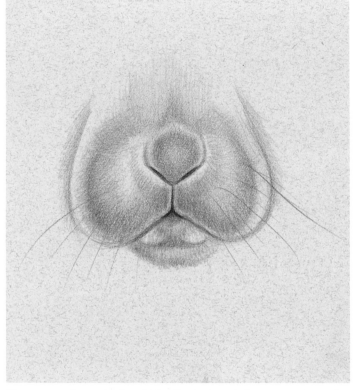

The nose and mouth of a rabbit. Like the horse, the nose and mouth are very soft. This is a characteristic of vegetarians and grazing animals.

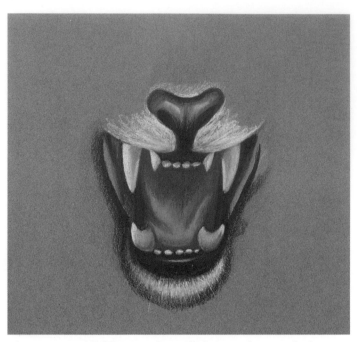

The open mouth of this tiger shows the large teeth it uses for hunting. Each of these teeth has the five elements of shading and many colors that must be captured. Using Prismacolor makes them look shiny and wet.

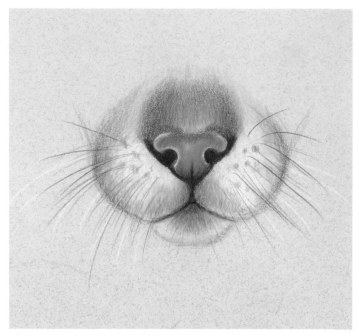

The nose and mouth of a wild cat. A domestic cat has the same general shapes, only smaller.

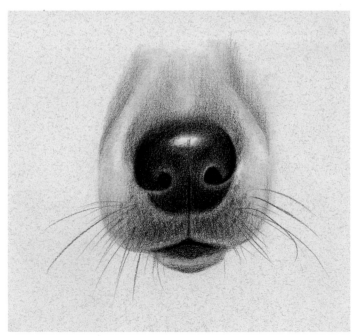

The nose and mouth of a dog. The highlight on the tip makes the nose look shiny.

NOTE —

When drawing whiskers, be sure to look for the "dot" where it originates. Use very quick strokes when drawing them in.

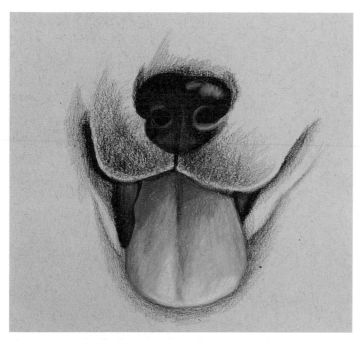

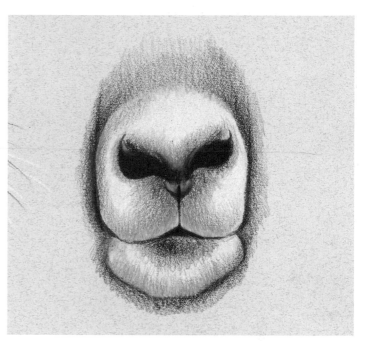

The open mouth of a dog. The tongue has a crease down the middle; notice the shadow it creates. Look at the varying colors and tones and the reflected light around the edge.

A sheep has unusual-shaped nostrils. Each animal has distinct nostril shapes seen just in that breed or species.

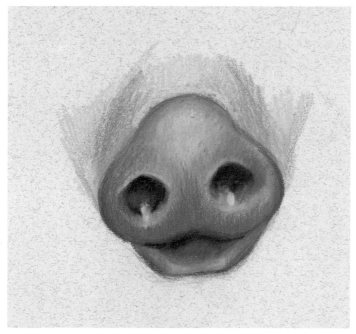

This pig has a very recognizable nose!

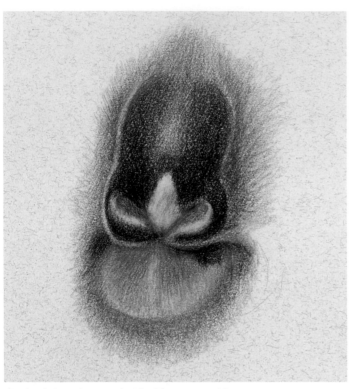

The koala bear has another highly recognizable nose.

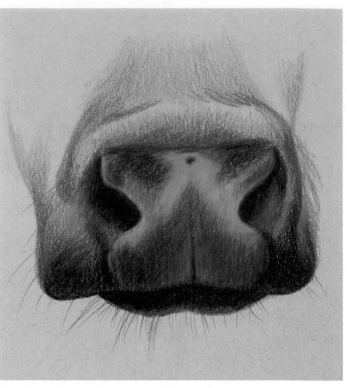

The flat, soft nose of a cow is used for grazing.

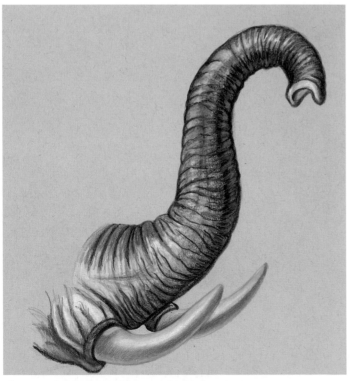

This is probably the world's most highly functioning nose.

Ears

The ears of your animal can make or break your artwork. They must have the proper shape and depth to look realistic. Ears are very complex at close examination. They are layered, and your drawing must show the overlapping features and details.

Study the large variety of ears seen in animals of various kinds. Some are huge and hanging down while others are barely discernable. Some are pointy while others are almost perfect circles. Whatever shape and size they are, be sure to accurately draw them in your work.

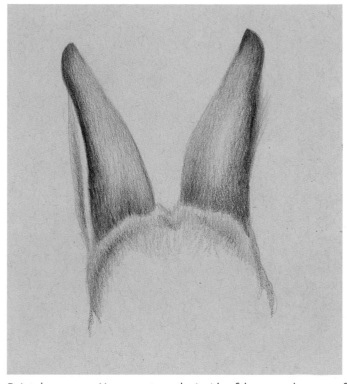

Pointy bunny ears. You cannot see the inside of these ears because of how they connect to the head.

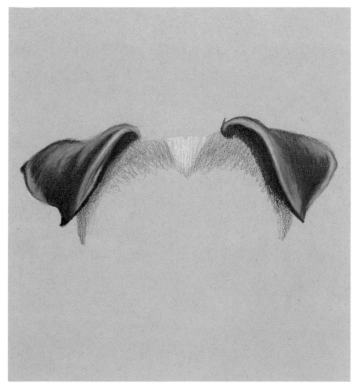

Droopy dog ears. Look for the reflected light seen along the edges.

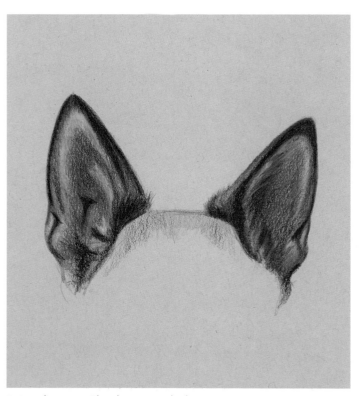

Pointy dog ears. The shapes inside the ears are very important.

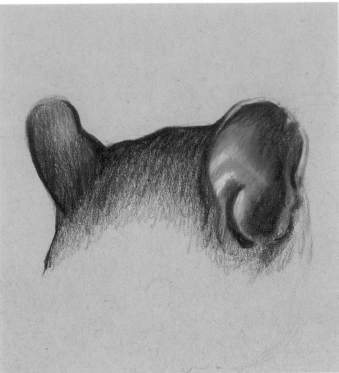

Round mouse ears. The inside of these ears have many small shapes to capture.

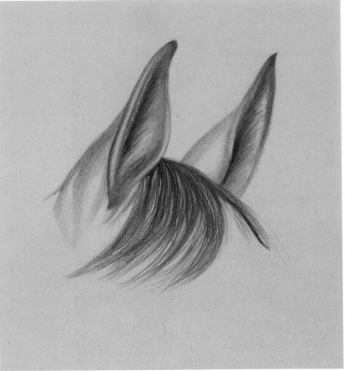

The ears of a horse. The hair inside these ears is very visible.

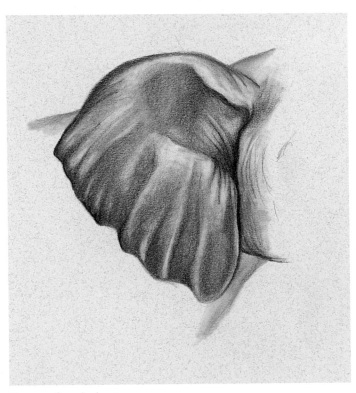

The ear of an elephant.

Feet

You may think that studying animal feet may sound silly, but it would look pretty funny to draw animals without them! Again, the differences between the species are enormous.

I think of the feet in terms of basic shapes and go from there. Look for the five elements of shading when you study their shapes. They must be present in order for them to look realistic.

As with the other features, the feet have distinct characteristics that apply to their use. A small squirrel has tiny fingers with sharp little claws that grip. That is how they dig for food and hold on to round nuts and berries.

Some animals have claws while some have hooves. Some are designed for climbing while others are designed for running or walking. A primate has useful hands and feet that resemble our own. Study these differences carefully.

The paw of a squirrel. It has sharp claws and a "hand-like" quality that makes it very useful.

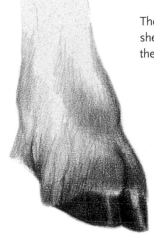

The cloven hoof of a sheep is divided in the middle.

The hoof of a horse, which is solid in shape.

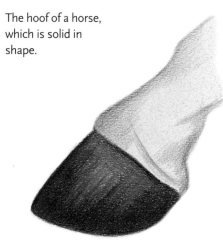

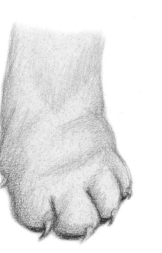

The paw of a puppy, which is designed for running.

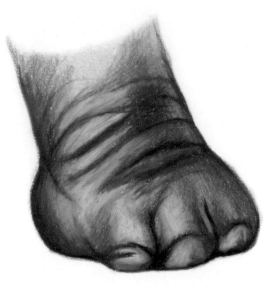

The foot of an elephant. This large, wide foot is designed for carrying the weight of the animal as it walks.

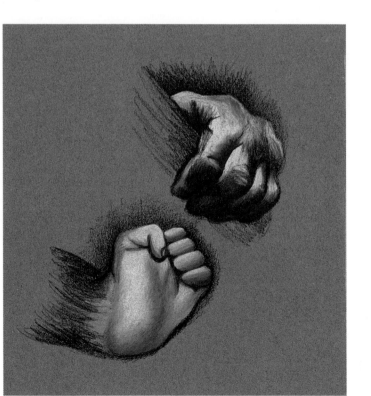

The foot of a primate closely resembles a human's foot.

Putting it All Together—Draw a Rabbit Step-by-Step

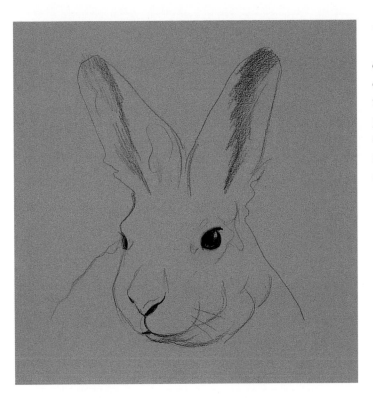

1 Using your Black Verithin only, fully render in the eyes. But be careful, the eyes should not be a solid color. Be sure to differentiate between the tones of the iris color and the pupil. The small catchlight makes the eye look shiny. Next, start adding some darkness to the inside of the ears.

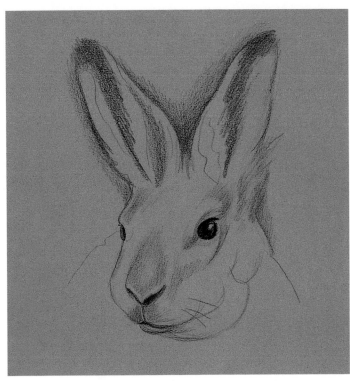

2 Since the bunny will be white, I toned the background to make the edges show up. This also prevents you from having to outline the ears to make them show up.

With your Black pencil, continue filling in the dark areas of the ears and the contours around the eyes and the nose. Keep a very sharp point on your pencil and use a light touch. Place your pencil lines close together for an even application of tone.

COLORS USED

Black, Dark Brown, White, Terra Cotta and Turquoise.

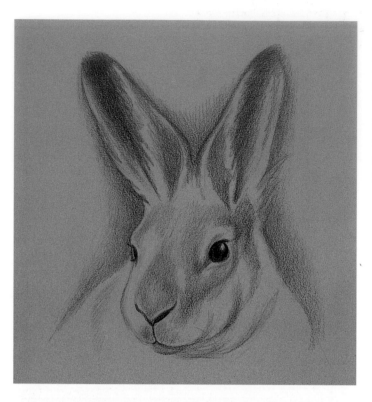

3 Continue deepening the tones again using Black only. Notice how the shape and form of the bunny is now appearing more realistic. The darkness around the bunny makes the animal stand out. The drawing actually could be considered complete at this stage if you wanted it to remain in black and white.

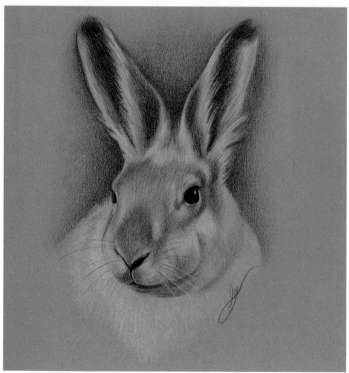

BUNNY RABBIT
Verithin pencils on no. 3307 Devonshire Blue mat board
14" x 11" (36cm x 28cm)

4 To continue creating the realistic look of the rabbit, add Dark Brown and Terra Cotta into the dark areas of the drawing overlapping the Black that was already there. With a sharp point to the pencil, let some of the pencil lines show up to represent the look of fur. Next, add White to the open areas from the previous drawing. This will completely change the look of the drawing because the White sharply contrasts against the gray tone of the board.

To create more interest in the drawing, add some Turquoise to the background. Let it overlap the Black and fade into the color of the board. Add a little of the Turquoise into the colors of the bunny. Reflective color is very important to realism.

Hair and Fur

One of the drawbacks of drawing animals is the amount of time it requires to accurately depict the fur. This is the area in which I receive the most grief when teaching my art classes. The hundreds of layers necessary to build up the look of hair and fur can be a time consuming, laborious process. However, look at the results when you are done!

This drawing of a koala bear doesn't look that complex. But this animal has very short, coarse hair. It requires many short, quick little strokes to make it look authentic. A close-up portrait of an animal makes the need for showing the hair even more important.

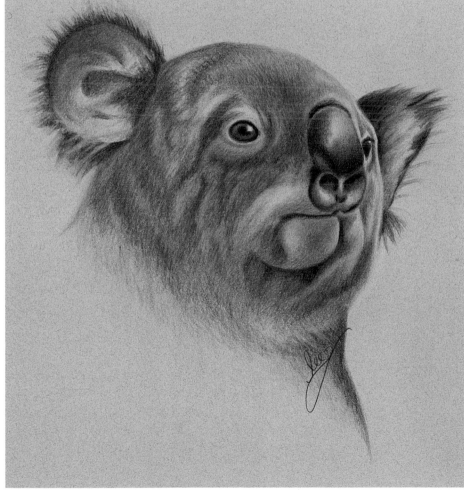

Verithin pencils, with their sharp leads and fine points, helped create the short coarse fur of the koala bear. It takes many layers of quick, short, overlapping pencil strokes.

KOALA BEAR
Verithin pencils on Strathmore Renewal paper
14" x 11" (36cm x 28cm)

DON'T make your pencil lines harsh and deliberate!

DO use a quick stroke to taper the end of the line.

COLORS USED

Dark Brown, Dark Umber, Terra Cotta, Black and White.

Drawing Short Hair—Step-by-Step

The following examples show how to apply the pencil lines to make them appear as hairs. It is a quick stroke that makes the pencil lines taper at the ends. Use a flick of your wrist, lifting up as you end the line.

A hard, deliberate stroke makes the pencil line too harsh and even in width. This makes the line fat and unnatural looking.

1 Always start by filling in some light tone first. You never want the color of the paper coming through your pencil lines.

2 Begin by adding pencil lines in the direction that the fur is growing.

3 Continue to add pencil lines with a quick stroke until the fur fills in. Build up the layers until you have the fullness you need.

Long Hair and Fur

The length of the hair is represented by the length of your pencil lines. For the long hair of this orangutan, I used long, sweeping lines that followed the hair direction.

Because of the many layers of hair on this animal, various shades of light and dark were created. These tonal changes are important to the overall look of the hair. It is the contrast of light and dark that gives it depth. Highlights are added on top to make them appear as reflections and not white streaks of hair.

This drawing was done on suede board. Its surface helped give the illusion of the softness of the orangutan's hair. The paper also helped create the blurred background, which makes it appear as though it is in the distance. To make something appear further away, it should have less detail and softer color.

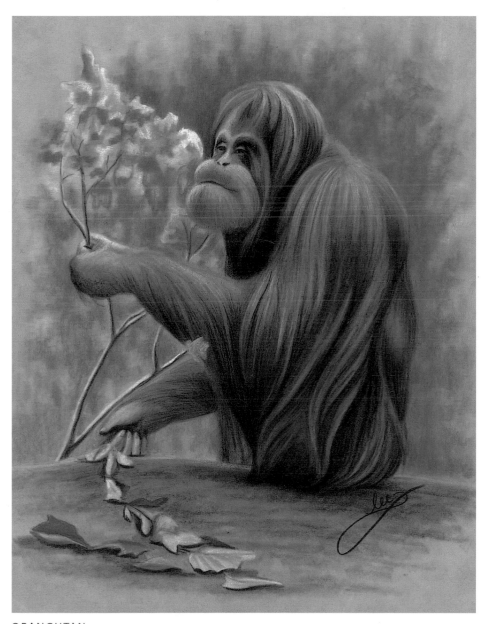

ORANGUTAN
Prismacolor on no. 7102 Dune suede mat board
14" × 11" (36cm x 28cm)

DON'T use harsh, deliberate lines!

DO use soft, gentle lines that follow the shape of the hair.

NOTE —
Because Prismacolor does not burnish on suede board, it is not necessary to spray it when you are finished.

COLORS USED

Orangutan: Dark Brown, Light Umber, Terra Cotta, Peach, Pumpkin Orange, Black and White.
Foliage: Apple Green, True Green, Dark Green, Chartreuse, Olive Green, Pumpkin Orange, Dark Brown and White.
Ground: Dark Brown, Black and White.

Drawing Long Hair—Step-by-Step

The following examples show how to draw long hair. Notice how the length of the pencil line represents the length of the hair. All hair, short and long, requires many layers to make it look real. Again, a quick pencil stroke is essential. This makes the lines thinner at the ends. Drawing too deliberately will make the lines look unnatural.

1 Place some base tone down in the shape of the wave.

2 Using quick pencil lines that follow the direction of the hairs, start to fill in the hair strands.

3 Keep adding pencil lines until the hair looks thick and full.

Patterns and Markings

Many animals have built-in camouflage due to the colors and markings of their fur. This makes the job of an artist much more of a challenge. Each of these drawings were complicated by the patterns seen in their fur, but they were fun to do.

The tiger has some of the most beautiful markings seen in nature, especially the various colors contrasting against the black stripes.

To draw the colors and patterns seen here, it is important to draw in the lightest colors first. If the black is applied first, it will smear into the other colors.

Whiskers are done last, since they overlap the rest of the face. These white whiskers were first scraped out with a craft knife because of the heavy dark color underneath. White pencil will not stand out against black without a little help. This is only a problem when you are working with Primsacolor, because of the wax build-up. Scraping must be done carefully so as to not gouge and damage the paper. The tip of the knife works best.

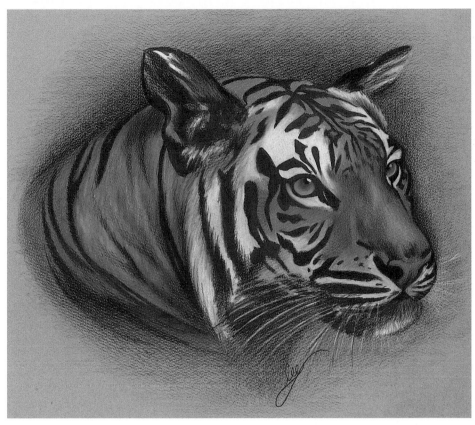

TIGER
Prismacolor pencils on no. 3347 Ashen mat board
16" x 20" (41cm x 51cm)

COLORS USED

Fur: Dark Brown, Light Umber, Terra Cotta, Mineral Orange, Yellow Ochre, Deco Yellow, Black and White.
Nose: Mineral Orange, Black and White.
Eyes: Dark Brown, Light Umber, Yellow Ochre, Deco Yellow, Black and White.
Whiskers: Black and White.
Background: Dark Green, Black, Olive Green and Yellow Ochre.

The leopard was done much the same way. I used Studio pencils the same amount of time as on the tiger, but the colors were not as vivid. Less texture was required. I drew in the lighter colors first, then blended them in with a tortillion to make them appear soft and smooth. I realized I didn't need to show hair texture like I did for the tiger.

I filled in all of the black spots after I completed the color.

COLORS USED

Fur: Terra Cotta, Copper Beech, Sienna Brown, Chocolate Brown, Indian Red, Straw, Ivory Black and White.
Eyes: Sienna Brown, Straw, Ivory Black and White.
Background: Bottle Green, Sienna Brown, Terra Cotta, Delft Blue and Magenta.
Foreground: Sienna Brown, Chocolate, Terra Cotta and Delft Blue.
Whiskers: White

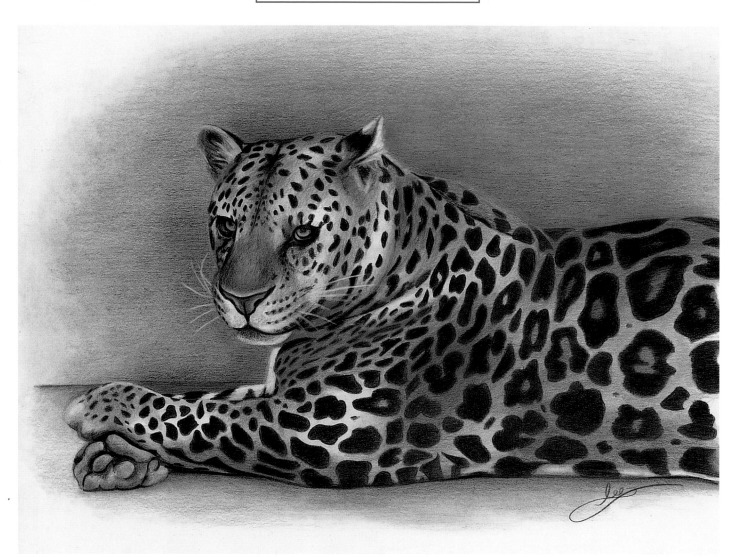

LEOPARD
Studio pencils on no. 1008 Ivory mat board
16" x 20" (41cm x 51cm)

When drawing this fawn, I started with the darker colors first. However, this time I left the spots "open" to appear white. I used Verithin pencils for this study; you can see the texture of the board showing through. I like the graininess that this pencil produces.

This drawing would also have looked nice drawn with Studio pencils. There isn't a lot of texture or obvious direction of the hair showing, so a blended approach would have looked pretty.

Compare the three techniques, and see which one you like the most. Can you see the differences in their appearances, and why the type of pencil you use is so important? Look at the backgrounds. Notice how different each one looks.

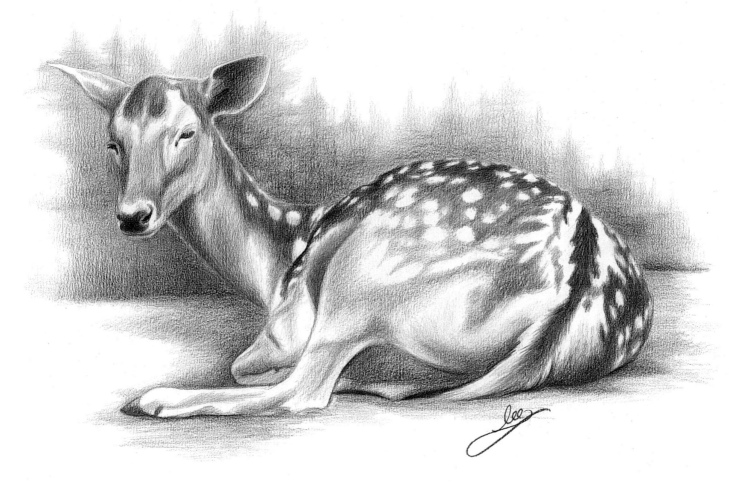

FAWN
Verithin pencils on no. 3297 Arctic White mat board
11" x 14" (28cm x 36cm)

COLORS USED

Deer: Dark Brown, Terra Cotta and Black.
Background: Dark Green and Black.

There will be times in your work where just one of the pencil brands will not give you the look you want to achieve. The zebra illustration shows what I mean. Look closely and you will see two different techniques: burnishing with Prismacolor and blending with Studio pencils. The two techniques gave me the deep black and bright white I wanted for the zebra and the soft blending of color for the background.

COLORS USED

Zebra: Black and White Prismacolor. I added French Grey 20% into the white stripes.
Nose: Black and Dark Brown Prismacolor pencils.
Background: Magenta, Smalt Blue and Prussian Blue Studio pencils.

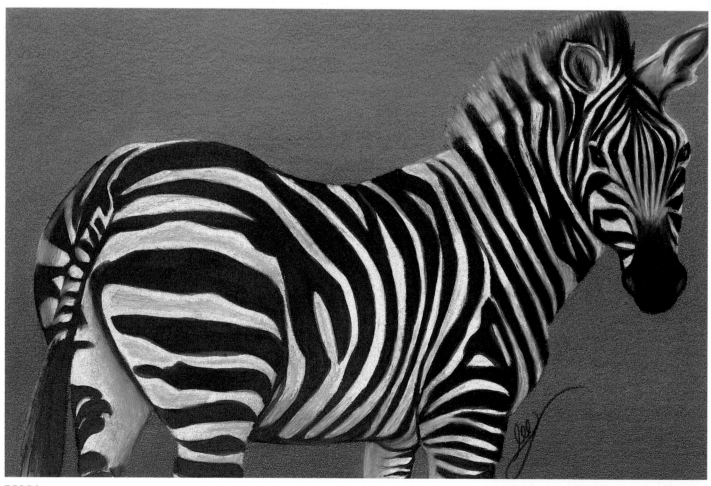

ZEBRA
Prismacolor and Studio pencils on no. 1043 Autumn Gray mat board
6" x 11" (15cm x 28cm)

NOTE—
The background colors were blended with a tortillion. I added some of these colors into the white areas of the zebra to look reflective.

Texture

Texture is an important element to capture in your animals. Sometimes the hair direction is varied, creating the look of patches or clumps.

This cow has a lot of texture on the top of his head. I used Prismacolor to build up this heavy area. I concentrated on first applying a lot of white, then adding darker colors to create patterns. These patterns of light and dark created the look of thick layers.

I used the pencil somewhat on its side for this approach. As I worked down the face, I used more of the point of the pencil to create the hair strokes. You can see these strokes on the neck as well.

This sheep was done much the same way. A heavy build-up of colors, using the pencil "on the flat," will give you the textured look you see in the sheep's wool.

It is the patterns of light and dark that are so important.

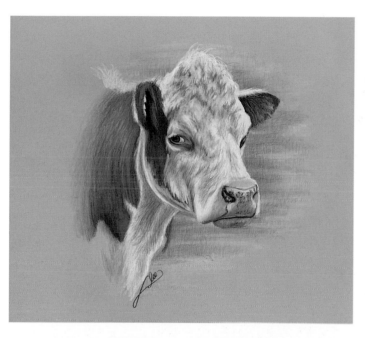

COLORS USED

Head: White, French Grey 30%, Light Umber, Cool Grey 70% and Yellow Ochre.
Ears and back: Terra Cotta, Dark Brown, Yellow Ochre and Mineral Orange.
Nose: Light Peach, Sand, Light Umber, Black and White.
Background: True Green, Apple Green, Light Aqua and Dark Green.

COW
Prismacolor pencils on no.928 Extra Light Gray mat board
16" x 20" (41cm x 51cm)

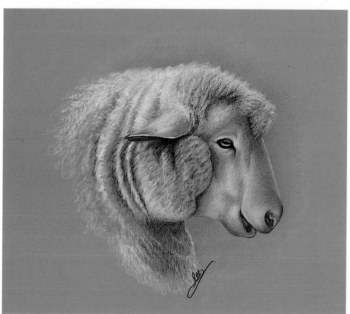

COLORS USED

Wool: White, Deco Yellow, Goldenrod, Dark Brown, Light Umber and Black.
Eye: Goldenrod, Deco Yellow and Black.
Nose: Peach, Deco Yellow and Black.
Background: Peacock Green, Aquamarine and Light Green.
Note: Look closely and you can see the Light Green of the background reflecting into the face of the sheep.

DRAWING OF A SHEEP
Prismacolor pencils on no. 3331 Sage mat board
16" x 20" (41cm x 51cm)

Sometimes the animal you are drawing will have a combination of fur types.

On this example of a lion, you can see long, thick hair in the mane combined with short, coarse hair on the face.

I used Prismacolor pencils for this project. You can see the heavy application of color in the mane. The mane required a lot of layers and a burnished approach to make it look this full.

For the face, I used pencils with a sharp point and a layered approach. The slight texture of the mat board was then able to come through, giving the fur a textured look. I used a craft knife to scrape out the whiskers before applying the white to them.

COLORS USED

Hair and fur: Dark Brown, Terra Cotta, Mineral Orange, Goldenrod, Light Umber, Jasmine, Black and White.
Eye: Goldenrod, Deco Yellow, Black and White.
Nose: Light Umber, Black and White.

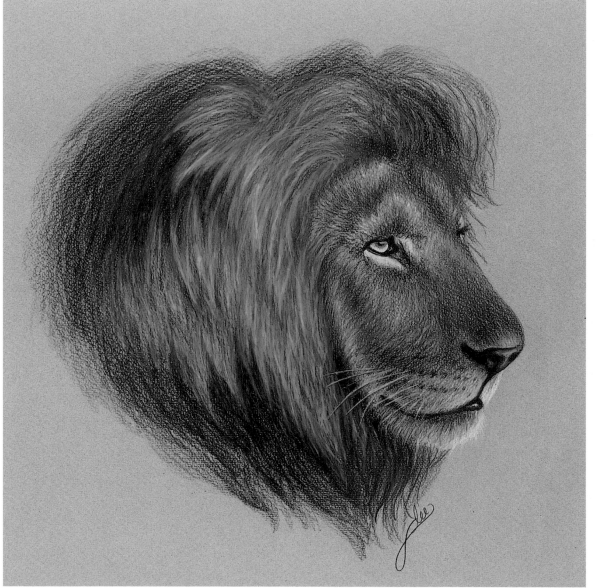

KING OF BEASTS
Prismacolor pencils on no. 3311 Granite mat board
16" x 20" (41cm x 51cm)

Verithin Pencils

All of these illustrations were done with Verithin pencils on a light-colored mat board. I chose the light background color to help enhance the color of the animal. For the lop-eared bunny, the gold color of the mat board helped me produce the color of the bunny. Because Verithin does not build up and cover the paper, the paper shows through.

Look at the yellow color of the fur, particularly in the shadow areas. Rather than just using black to deepen the golden color, I used the opposite, or complement of yellow, which is violet. (Complements are colors opposite each other on the color wheel.) This created a much richer color without "killing" it with black. I also used the violet tones in the background to make the bunny stand out more. Any time complementary colors are placed next to one another, they stand out.

The direction of this rabbit's fur was very obvious, so it was a good project for Verithin pencils. The thin lines produced by these pencils resemble the texture of hair.

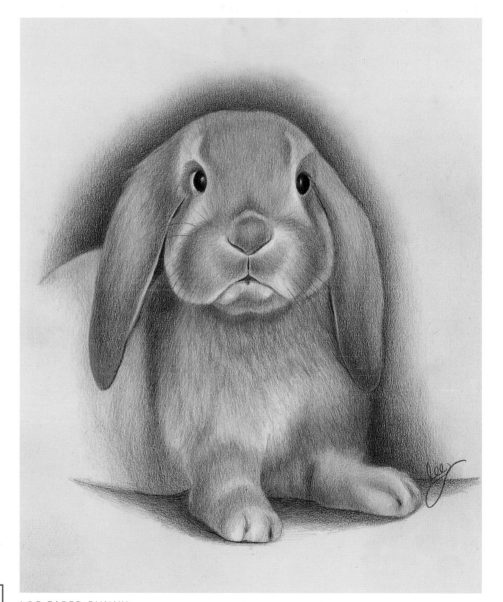

LOP-EARED BUNNY
Verithin pencils on no. 912 India mat board
10" x 10" (25cm x 25cm)

COLORS USED

Bunny: Goldenrod, Dark Brown, Terra Cotta, Mineral Orange, Violet, Magenta, Black and White.
Eyes: Black and White.
Background: Violet, Magenta and Dark Brown.
Foreground: Dark Brown

This was drawn entirely with a Dark Brown Verithin. It gives the drawing an old-fashioned look, resembling the look of a sepia-tone photo.

This drawing was taken from a newspaper article written years ago about my good friend Bob. He has been mentioned in my previous books, and owned a horse ranch where I grew up. As a young adult, he took my dog Sparky to live with him on the ranch.

I had the copy of the newspaper article pinned to my studio wall for a long time. It actually was a fax copy, and had a funny brown color to it.

One day the paper slipped and I noticed it hanging upside down from across the room. Suddenly, after all those years, I saw it differently. It no longer was a picture of Bob; it was a wonderful study of dark and light shapes. It looked more like an abstract, and I immediately wanted to draw the shapes I saw.

I stopped viewing the actual subject and saw it as shapes. The process was slow because the layered technique of Verithin takes more time. However, piece-by-piece, the drawing developed.

Because I was not concerned with accuracy, my drawing was much more accurate.

To my surprise, when I finished and turned the drawing over to look at it, it was a wonderful likeness. I then also realized that certain areas, which I had seen just as shapes, were actually recognizable objects. The

light and dark shapes in the background are, in reality, the old farmhouse and a fence. The dark shapes to the left of Bob are the shadow of a tree. Even a part of my cat can be seen behind the handrail. I never even saw those things in the photo until I drew it!

COLORS USED

Dark Brown

BOB AND SPARKY
Verithin pencils on no. 1008 Ivory mat board
10" x 8" (25cm x 20cm)

Drawing a Grizzly Bear Step-by-Step

Anytime I want to show a lot of individual hair strokes and texture, I choose Verithin pencils. Their hard, thin leads produce nice thin lines.

This grizzly bear is full of bristly fur, so I chose it for this exercise. Compare your line drawing from page 26 to the photograph. When you are sure of its accuracy, remove the graph lines with a kneaded eraser.

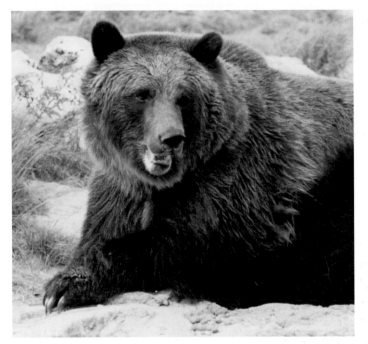

Photo of a grizzly bear from page 26.

Check your drawing from page 26 for accuracy. Remove the grid lines from your drawing with a kneaded eraser.

COLORS USED

Black, Dark Brown, Dark Umber, Terra Cotta and Yellow Ochre.

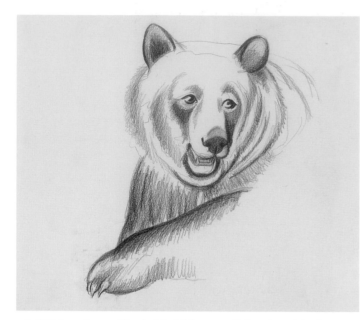

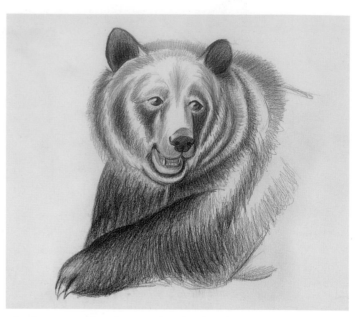

1 With a sharp Black Verithin pencil, begin with the eyes and nose. Then place tone in the ears and begin the dark areas of the fur. Be sure to look for the direction of the fur and place your pencil lines in accordingly. This stage already starts creating form.

2 Continue developing the depth of the tone with Black. Then, with Dark Brown and Dark Umber, overlap the Black and continue filling in the fur. Dark Brown is a little lighter than the Dark Umber; it gives the fur a touch of red. Keep going with the hair direction.

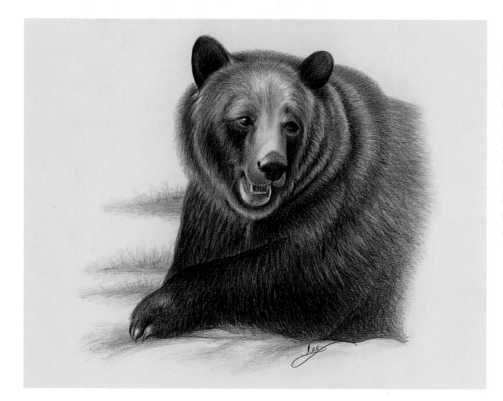

3 Add some Terra Cotta to deepen the red tones in the fur, and add some Yellow Ochre in the face. Keep adding your tones until you have enough layers to depict the fullness of the bear's fur. Be patient! This process takes a lot of time, so don't quit too soon. The biggest error that beginning artists make is not going far enough with their work. Add some green and brown tones to give the illusion of ground and grass.

Prismacolor Pencils

The surroundings of this dog are reflecting into the shininess of his fur. I use a phrase in my art classes that makes a lot of sense. "White isn't white, and black isn't black!" Both colors are just an undertone, with the colors surrounding it reflecting off of it.

This is a drawing of my old dog Brandy. She loved to play ball on the stairs. The colors surrounding her are reflecting on her white fur. Can you see the pink tones from the carpeting repeated on her body?

I used Prismacolor pencils two different ways on this drawing. I used the heavy, burnished approach for Brandy to make her hair look shiny.

I used the layered approach on the stairs to make the carpet look textured.

Notice the area of reflected light along the edge of the stairs? This is what makes them appear dimensional. Without that reflected light, they would look flat.

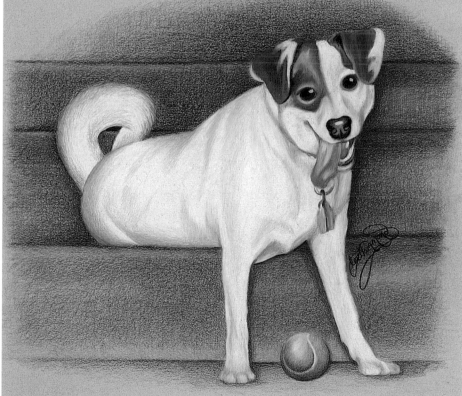

BRANDY
Prismacolor pencils on no. 3310 Regent Gray mat board
11" x 14" (28cm x 36cm)

COLORS USED

Fur: White, Cool Grey 30%, Clay Rose and Light Umber.
Face: Terra Cotta, Light Umber, Sienna Brown, Beige and Dark Brown.
Eyes: Dark Brown, Black and White.
Nose: Dark Brown, Henna, Black and White.
Tongue: Pink, Henna, Terra Cotta and White.
Stairs: Tuscan Red, Dark Brown, Peach, Henna and Raspberry.
Tennis Ball: Sand, Dark Brown, Cool Grey 70%, Tuscan Red and White.

This tiger cub is another example of how to use Prismacolor two different ways. The colored, orange part of the fur was done with a lighter, layered application. This allowed the texture of the paper to come through. The white areas and the black areas were burnished to fill it in.

I also used a layered approach to create the tree bark and background. The contrast between textures gives the drawing more interest.

Texture is very important to your drawing. In this drawing of my cat, Meowser, I used a craft knife to scratch light hairs into the dark fur. (Yes, I've had a lot of pets!) This type of cat has a mixture of color in the dark areas. These areas resemble stripes of light and dark. Scraping gives you much finer lines than draw-ing. It looks realistic, doesn't it?

Sometimes your photo reference will have bright colors to capture. In that case you will want to use a heavy, burnished approach for the entire drawing.

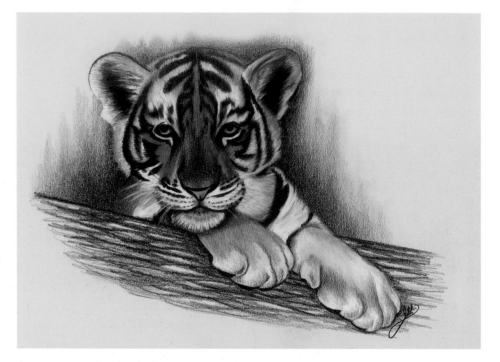

TIGER CUB
Prismacolor pencils on no. 912 India mat board
10" x 15" (25cm x 38cm)

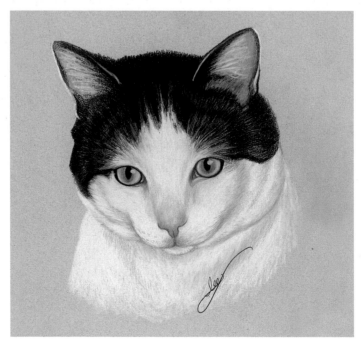

MEOWSER
Prismacolor pencils on no. 3304 Camelot mat board
8" x 10" (20cm x 25cm)

Drawing a Dalmation Step-by-Step

Prismacolor pencils are excellent for creating rich color with good coverage. When I wanted to draw this dalmatian, I knew it was the pencil I needed to create the bright white areas. By using gray paper, the white stands out even more.

Using the line drawing from page 27, compare the drawing to the photo, and check your shapes for accuracy. Once you are happy with the results, remove the graph lines with a kneaded eraser.

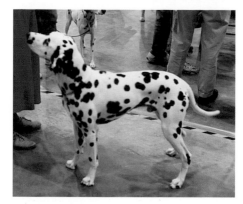

Photo of a dalmatian from page 27.

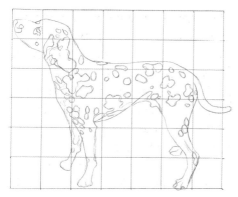

This line drawing resembles a map. It is a large grouping of many shapes.

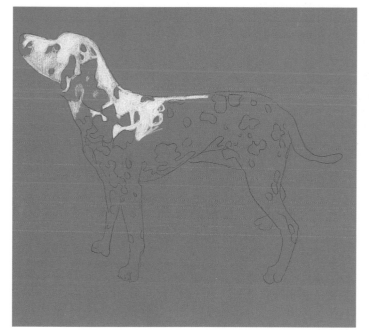

1 Begin by placing in the light colors. Remember, if we put in the Black first, it will smear into the White when it is applied. Looking at the drawing as a map, begin filling in the White.

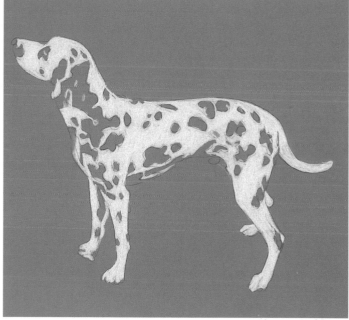

2 Continue filling in White until the entire dog is completed.

COLORS USED

White, Yellow Ochre, Mineral Orange, Warm Grey 50%, Light Umber, Peach and Dark Brown.

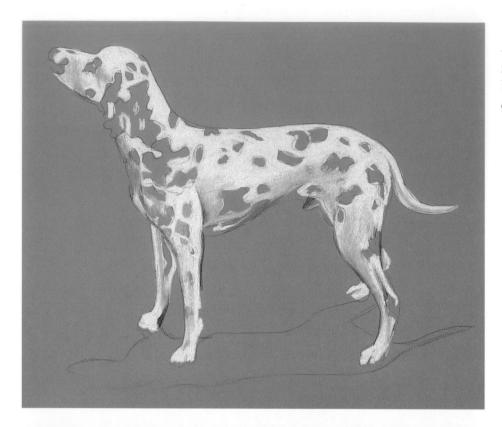

3 Look at your shadow areas. There are many colors reflecting into the white areas that need to be blended in. This is what makes your drawing look real.

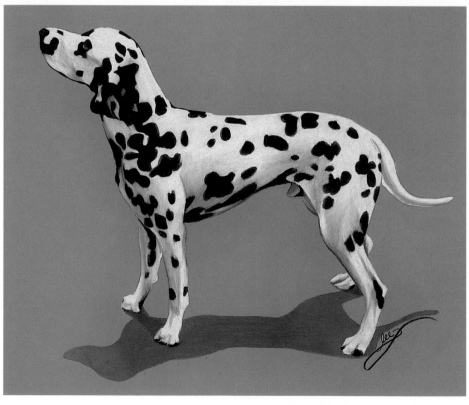

4 Finish the dog by filling in the black spots. Add the shadow under the dog with Warm Grey 50%.

NOTE —
Because Prismacolor is such a waxy medium, it is very important to spray your drawings with a fixative when you are finished. When left unsprayed, the wax in the pencils rises to the surface of your drawing, causing it to look hazy and foggy. This milky-looking film is called wax "bloom." Once the drawing is sprayed, this no longer happens, and your colors look more vivid and pure.

Studio Pencils

The following examples illustrate how you can use Studio pencils to capture the magic of animals.

The next two illustrations are perfect examples of how you can use Studio pencils to really bring out the skin and texture of animals, such as an elephant and a rhino.

Look at how realistic these illustrations appear. By blending the tones with a tortillion, the contours of the animals are created. Study the subtle transitions of tone. It closely resembles the five elements of shading exercises we did at the beginning of the book. Look for the areas of reflected light that give the shapes their roundness.

Also, study the background and foregrounds. I used a combination of blending and texture. The further back it is, the more blending I used. Adding some detail and texture to the areas closer up gives a better illusion of distance.

COLORS USED

Elephants: Chocolate, Terra Cotta, Copper Beech, Brown Ochre and Ivory Black.
Background: Juniper Green and Ivory Black.
Foreground: Sienna Brown, Copper Beech and Ivory Black.

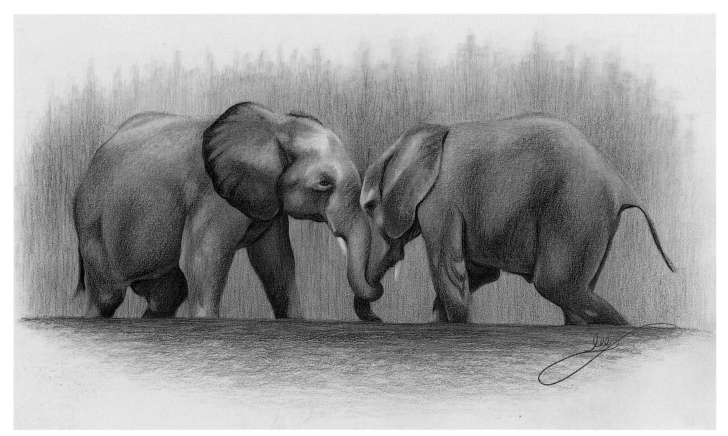

ELEPHANTS
Studio pencils on no. 912 India mat board
10" x 14" (25cm x 36cm)

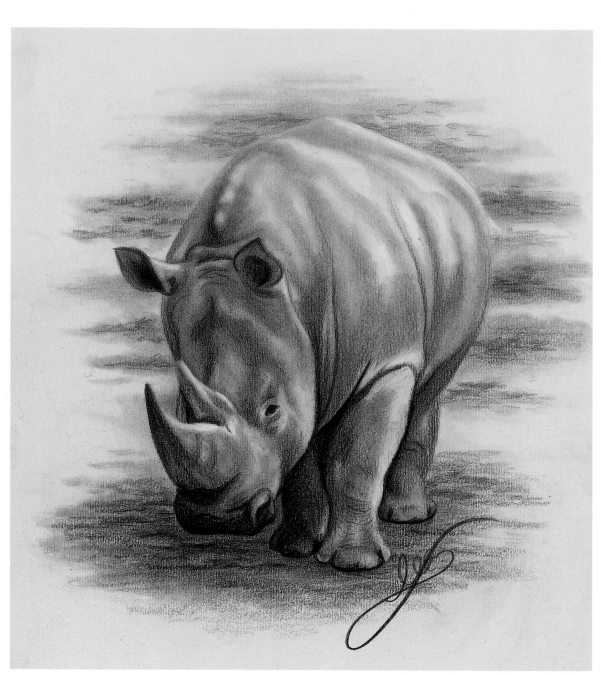

RHINO
Studio pencils on no. 1009 Light Jonquil mat board
10" x 8" (25cm x 20cm)

COLORS USED

Rhino: Chocolate Brown, Burnt Umber,
Copper Beech, Brown Ochre, Burnt
Sienna, Terra Cotta and Ivory Black.
Foreground and background: Chocolate,
Burnt Umber and Bottle Green.

This portrait of JoJo, a cute baby
Yorkie, was also done using two
techniques. The dark colors of the
dog were applied with firm pressure,
while the soft tones of the hands and
background were blended with a
tortillion.

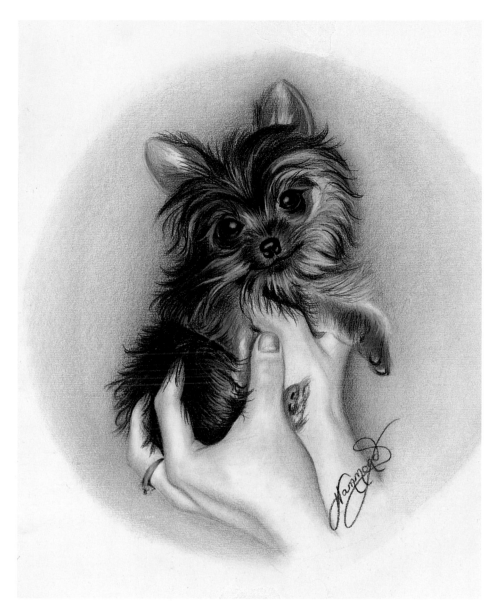

JOJO
Studio pencils on no. 1008 Ivory mat board
14" x 11" (36cm x 28cm)

COLORS USED

Dog: Ivory Black, Terra Cotta, Copper
Beech, Burnt Sienna and Burnt Umber.
Hands: Terra Cotta, Burnt Carmine, Pale
Vermillion and Copper Beech.
Background: Imperial Purple and
Kingfisher Blue.

A Squirrel Step-by-Step

I am using Studio pencils more and more in my artwork. I like the ability to use my blended technique with color to create soft tones, especially in background areas. These pencils can also be used heavily for a filled-in look. This small project of a squirrel will give you practice using the pencils both ways, for textured and blended areas.

Photograph of a squirrel.

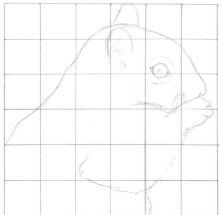

Using the line drawing from page 29, check your drawing for accuracy, and then remove the graph lines with a kneaded eraser.

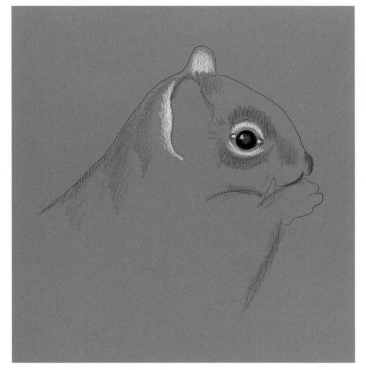

1 Using Ivory Black and Sepia, draw in the pupil of the eye. The inside of the eye is the lighter color, with the Black around the rim. Be sure to leave a spot for the catchlight. Add some color around the eye and into the nose with Burnt Sienna. Add the White to the catchlight and around the eye. Place some addtional White into the ear. With Copper Beech, begin the brown tones in the back and front of the squirrel.

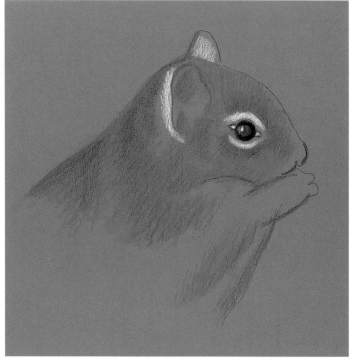

2 Add some more Copper Beech and Sienna Brown into the body of the squirrel. With a clean tortillion, blend the tones until they look nice and smooth. This will act as a foundation for you to build the rest of the fur.

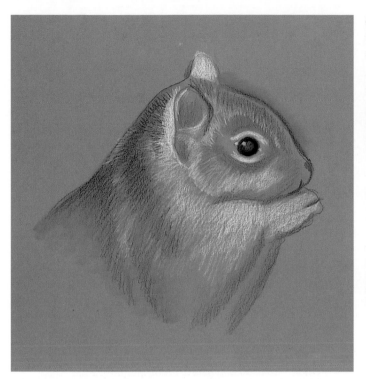

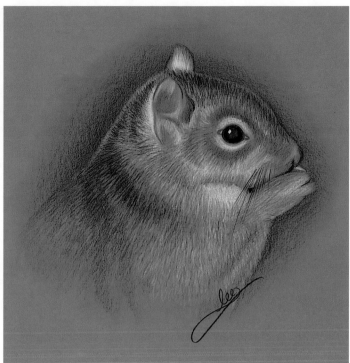

3 Now start developing the quick strokes of the fur with a sharp point on the pencils. Use White, Copper Beech and Ivory Black, watching for the patterns of color and hair direction. Also, add Burnt Sienna and White to the inside of the ear and blend it smooth.

4 Add more color to the face of squirrel with Raw Sienna. Add some to the tips of the ears as well. Continue to add to the overall fullness of the fur with quick, short pencil lines. Use the White, Ivory Black and Copper Beech.

Create the background by using Juniper Green, Copper Beech and Ivory Black. Add the colors lightly, and blend together with a tortillion.

COLORS USED

Squirrel: Ivory Black, Sepia, Burnt Sienna, White, Copper Beach, Sienna Brown and Raw Sienna.
Background: Juniper Green, Copper Beech and Ivory Black.

NOTE —
When using tortillions, it is very important to keep them segregated according to color. You will not want to accidentally use a tortillion that has been previously used for a different color. I've accidentally blended blue into a brown area before because I wasn't paying attention!

Colored Pencils on Suede

The following pages show the wonderful variety of looks you can achieve with suede board. This is one of my favorites.

Although the colors of the horse are very rich, the paper makes them go on very smooth and look very soft. I chose a soft tan color, knowing that it would show through and help create the color of the horse.

Although the whole idea behind this paper is to create softness, certain areas need to be darker. Burnishing is possible for extreme tones, as seen in the eye, nostril and bridle. You can also see some firm lines in the mane and forelock.

This combination of techniques makes for a very realistic impression.

COLORS USED

Horse: Dark Brown, Terra Cotta, Light Umber, Sienna Brown, Tuscan Red, Yellow Ochre, Black and White.
Muzzle, mane and forelock: Black, White, True Blue and Tuscan Red.
Bridle and reins: Poppy Red, Tuscan Red, Sienna Brown, True Blue, Black and White.
Background: True Green, Apple Green, Chartreuse, Dark Green and Black.

PORTRAIT OF A HORSE
Prismacolor pencils on no. 7132 Whisper suede mat board
16" x 20" (41cm x 51cm)

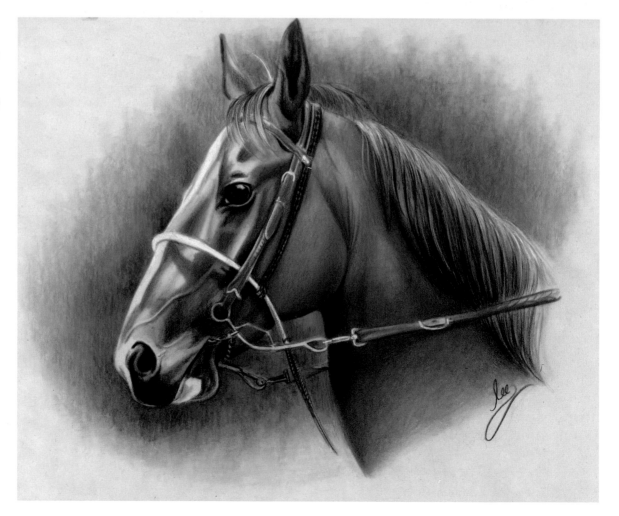

On this horse, I left more of the paper showing through. Because this horse is white, I chose white suede board to work on.

One drawback to this paper is that the white pencil does not cover well. For white subject matter, it is then important to use white board and allow the white to come through. I've tried to use a colored board and add the white, but it ends up looking flaky and mottled instead of smooth. Small areas, such as the bridle on the previous illustration, can be burnished in.

This is another example of reflective color. Although the color of the horse is white and dapple-gray, shades of blue and green reflect off of the fur. This is very obvious below the eye and on the muzzle. For the gray tones, I used a combination of warm and cool grays. The warm grays have more of a brown tone to them.

I used the Black with a light touch around the mouth area, allowing it to gently fade into the face. I applied more pressure inside the eye, ear and nostril to make those fill in more. Using firm, quick strokes, I created the forelock and mane. I added a little Dark Brown to give it a richer color.

Using Limepeel and Grass Green, I drew the grass area with a light touch first. I then used quick, vertical strokes to create the grass, approaching it the same way I did with the hair, but stroking upward.

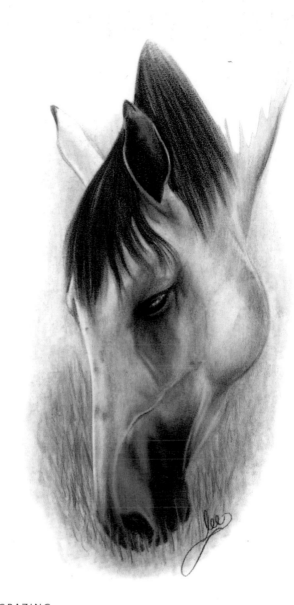

GRAZING
Prismacolor pencils on White suede mat board
14" x 11" (36cm x 28cm)

COLORS USED

Horse: Black, Dark Brown, Warm Grey 50%, Indigo Blue and True Blue.
Mane and forelock: Black and Dark Brown.
Grass: Limepeel, Grass Green, Dark Green and Light Aqua.

Both of these drawings were done on the same color suede board using similar colors. It's the way I used the pencils that makes them look different.

This lion cub has a different type of fur. The individual hairs are not as obvious, and the markings are not as distinct. I used the pencil with a duller point this time, sometimes using it on its side to fill in areas. It makes the cub look fluffier than the fox.

This drawing of a fox required a lot of small pencil strokes to indicate the short hair, and it required me to have an extremely sharp point on my pencil at all times.

I did not use a white pencil for this piece; all of the light areas are the color of the paper coming through.

Some of the blue tones from the background are reflected onto the fur. This is the most noticeable on the back and chest, but is also inside the ears.

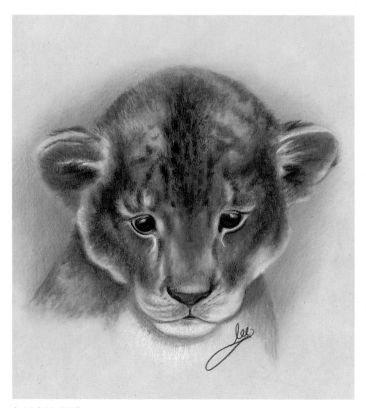

A LION CUB
Prismacolor pencils on no. 7132 Whisper suede mat board
14" x 11" (36cm x 28cm)

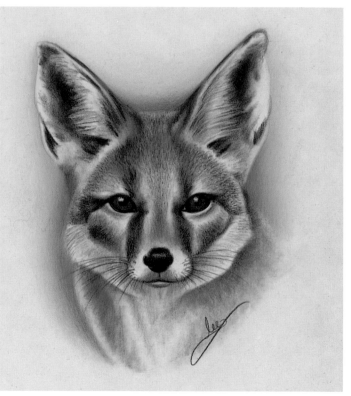

DRAWING OF A FOX
Prismacolor pencils on no. 7132 Whisper suede mat board
12" x 9" (30cm x 23cm)

COLORS USED

Eyes: Dark Brown, Black and White.
Fur: Dark Brown, Light Umber, Terra Cotta, Yellow Ochre, Black and White.
Background: Lavender and Clay Rose.

COLORS USED

Eyes: Black
Fur: Black, Burnt Umber, Terra Cotta, Light Umber, Yellow Ochre, Sienna Brown and True Blue.
Background: True Blue

Sometimes you will want to completely fill in your background. It will make the drawing look like a photograph instead of a portrait. It helps illustrate the scene and tell a story.

This little kitten had such soft color to its fur, but I wanted the background darker to make him stand out. Although it took a while to fill in the background to make it look that smooth, the effort was well worth it. It looks like the kitten is walking on a deck.

Notice how the dark background contrasts with the colors of the kitten and makes the eyes stand out even more. By making the tail section of the kitten darker, it looks like it is further back in shadow, giving the drawing a real sense of dimension. It actually looks like the kitten is walking toward you!

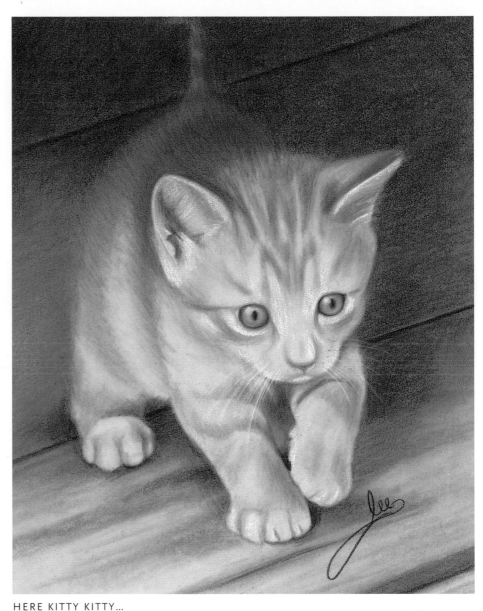

HERE KITTY KITTY...
Prismacolor pencils on no. 7132 Whisper suede mat board
10" x 8" (25cm x 20cm)

COLORS USED

Eyes: Indigo Blue, Black and White.
Fur: Sienna Brown, Peach, Terra Cotta, Mineral Orange, Tuscan Red, Dark Brown and White.
Background: Black, Cool Grey 70% and Indigo Blue. There is a touch of Tuscan Red in the shadow under the kitten.

Colors Are Not Always What They Seem

"Black isn't black, and white isn't white!"

The next two illustrations are perfect for that quote! Study them for both technique and color, and you can see why I choose suede board so often for my drawing surface.

This is a portrait of my old dog Tippy. Her shiny black fur took a while to build up. I used Aquamarine for the highlight areas of her fur to add more color. Rarely are highlights white in nature; they are created by the surroundings.

I used colors in the background that would repeat the colors seen in the dog, such as the Aquamarine, and the pink colors seen in the tongue.

This drawing was done on a gray background. Because of the white muzzle, chin and chest, I used a burnished approach with a white pencil to create them.

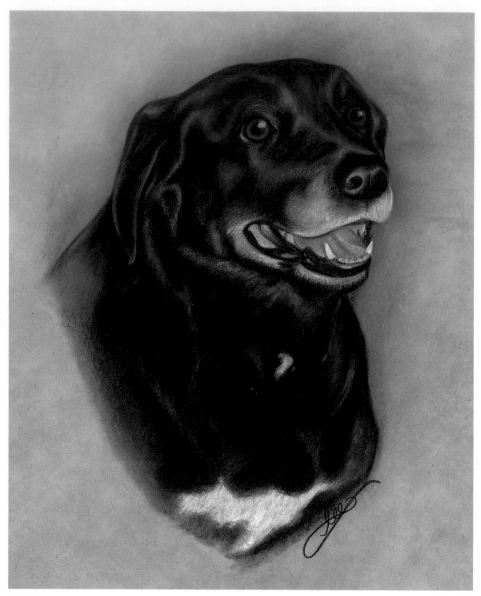

TIPPY
Prismacolor pencils on no. 7141 Platinum suede mat board
13" x 11" (33cm x 28cm)

COLORS USED

Eyes: Sienna Brown, Black and White.
Fur: Black, White and Aquamarine.
Tongue: Henna, Clay Rose, and White.
Background: Aquamarine, Process Red, Light Aqua, Salmon Pink and Lavender.

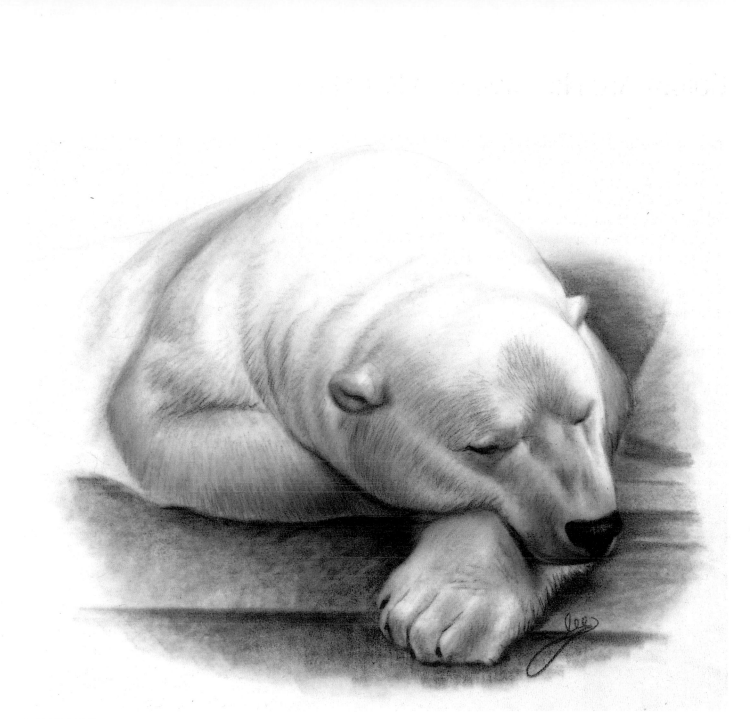

POLAR BEAR
Prismacolor pencils on White suede mat board
11" x 14" (28cm x 36cm)

COLORS USED

Polar bear: Aquamarine, Indigo Blue and Black.
Foreground: Aquamarine and Black.

Drawing a Puppy Step-by-Step

As the old saying goes, I've saved the best for last. Maybe it is the soft nap of the board or the gentle way Prismacolor glides over the surface. Whatever it is, I am thrilled with the results.

Realism is enhanced with this technique. Because of the board's surface, the edges of your subject are somewhat softened, preventing things from looking too hard-edged.

This project of the Lhasa apso puppy is a good place to start. The softness of the fur, and the delicate pastel background, lend itself perfectly to this approach.

As I mentioned in the graphing chapter, you can't graph your image directly onto suede because it cannot

be erased. That is why I had you draw your outline on a regular piece of copy paper.

To transfer your image to the suede, you can use two methods. The first method is using a transfer paper called Saral. It comes in sheets and rolls. I recommend the graphite color for this project, although it does come in a variety of colors, from light to dark.

Place the Saral paper under your line drawing like a piece of carbon paper, checking to make sure you position your work accurately before transferring. Be careful not to rub or slide your paper because it will smear across the suede.

When you have it placed on the sheet, tape the corners down to prevent it from moving. Then, with a medium point on one of your colored pencils, redraw the lines of your drawing. The image will transfer.

Any smudges can be lifted with a kneaded eraser. However, do not rub hard with the eraser. This will flatten and destroy the nap of the board.

You can also transfer your image by creating your own transfer paper. Simply turn over your line drawing and rub a thin layer of pastel or charcoal on the back. Rub it in so it isn't messy. Turn it over, carefully place it on the suede board, and tape it down. Redraw the image.

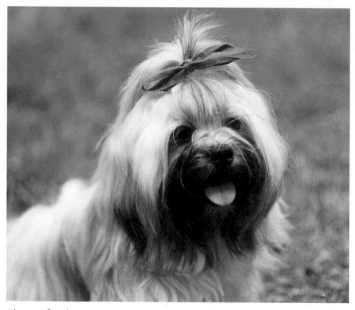

Photo of a Lhasa apso puppy.

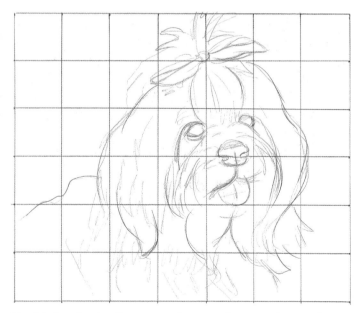

Use this line drawing from page 28, to transfer onto White suede board.

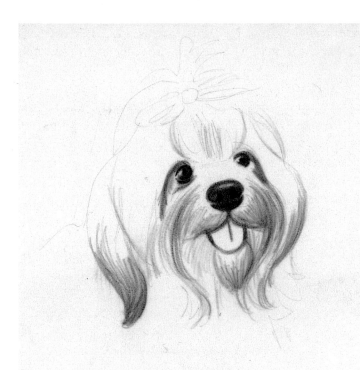

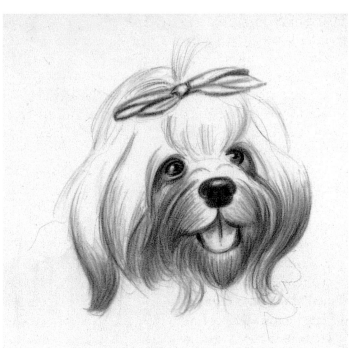

1 Once the image is transferred, begin with the eyes and nose. Use Dark Brown and Black for the eyes. Because the hair overlaps the eyes, it is important to create the recessed appearance with the shadows.

Fill in the nose with Dark Brown, and fill in the nostrils with Black. Then go over the nose with some Tuscan Red to make it look warmer.

Place some Dark Brown into the darker areas of the fur using quick pencil strokes that follow the direction of the hair.

2 With Tuscan Red, apply the bow. Use Tuscan Red in the fur areas and to begin the color of the tongue.

COLORS USED

Puppy: Black, Dark Brown, Tuscan Red, Pink, Deco Orange, White and Lavender.
Bow: Tuscan Red
Background: Aquamarine, Parrot Green, Deco Orange, Periwinkle and Process Red.

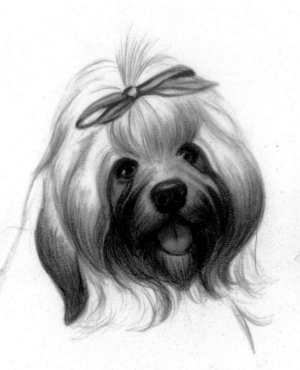

3 With Pink, deepen the color of the tongue. For the tip of it, use Deco Orange. Place some Pink into the bow. With Black and Dark Brown, deepen the color of the fur using the same quick strokes you used before.

4 To create the light edges of the dog, begin to place some color next to him. This background has a variety of colors. Begin with some Aquamarine, Parrot Green and Periwinkle.

To reflect some of the surroundings, add some of the same colors into hair of the dog. Add some additional colors, such as Lavender and Pink. Use White to add some light hair strands around the nose.

5 To finish off the background, use a variety of pastel colors. Feel free to add whatever you want; it is purely decorative. Overlap the colors so they fade into one another, for a soft, diffused look. I used the following colors: Periwinkle, Deco Orange, Pink, Aquamarine, Process Red and Parrot Green. All of these colors were applied with a very light touch so as not to produce pencil lines. I placed these colors into the coat of the dog as well for a pretty pastel coloration.

Other Options

There are unlimited options for drawing, literally hundreds of surfaces that can be explored—enough to fill another entire book. My goal when I write is to help you see and explore as many options as possible.

This drawing looks completely different from anything we've seen or covered previously. It is drawn on another type of mat board called linen. Its texture resembles that of a canvas with a woven surface. When drawing on this surface, the texture comes through.

This wolf's fur has a lot of texture, and by drawing it on this paper, the texture is exaggerated. It gives the drawing a very unique appearance.

Another paper you can try is called Colorfix, which is manufactured for pastel use. This heavily textured surface holds on to the powdery pigment of the pastels.

You can also use Studio pencils, which resemble pastels. Try blending the pencil pigment lightly with a tortillion in the background areas to make them appear blurred.

This technique gives your work a grainy look, a sharp contrast to the soft look of the suede board. Choose the paper that fits your creative expression; everyone is different.

I discovered all of these papers purely through experimentation. I fully recommend that you do the same, and draw on as many surfaces as possible. You will find your favorites just like I did.

COLORS USED

Eyes: Blue Violet Lake, Deco Blue, Black and White.
Nose: Black and Blue Violet Lake.
Fur: Black, Blue Violet Lake and Deco Blue.

NOTE —

All the white areas of the fur is the color of the paper coming through. I did not want white burnishing over the other colors, making it look too filled in. I wanted to let the texture of the paper come through.

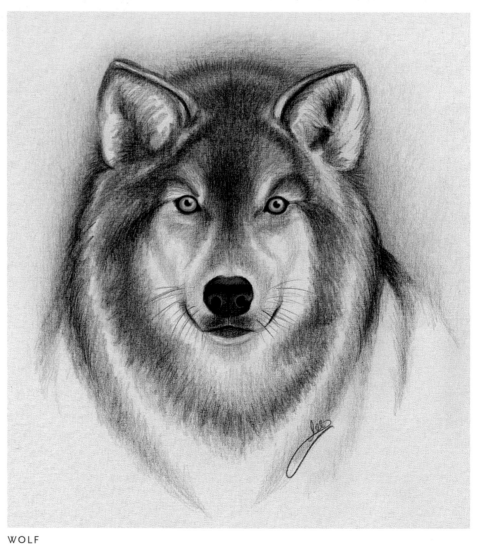

WOLF
Prismacolor pencils on no. 7526 Cream linen mat board
20" x 16" (51cm x 41cm)

This is another of my favorite techniques. For those of you that have read some of my other books, you will know that graphite is my favorite medium to work in. Many times I will take one of my graphite drawings and colorize it.

This drawing of my cat, J.J., was originally done in just graphite. It remained that way for years. Sometimes I get creative urges, though, and I have been known to yank a drawing right off the studio wall to make changes. That is what happened to this one.

J.J. was a black and white kitty, so I didn't want to do too much. I simply added some color to his eyes and his surroundings, changing the whole look.

Just by adding some Terra Cotta color to the bricks, the entire drawing changed. It was just enough color to make the kitty stand out. To make it look more realistic, I added some brown to the shadow area and put some reflected colors into the cat's fur. The brick color of the matting makes the whole project complete!

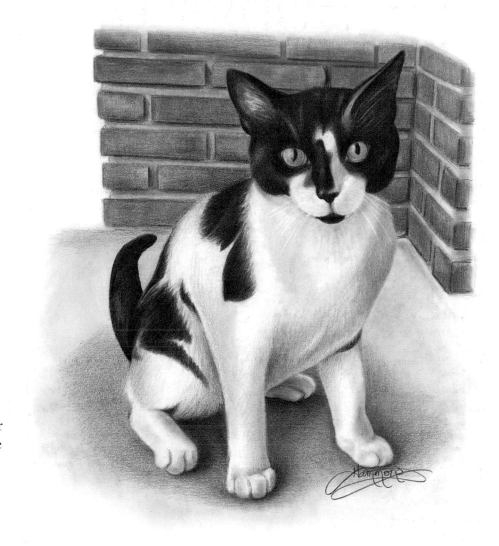

J.J.
Graphite tinted with Verithin pencils
14" x 11" (36cm x 28cm)

COLORS USED

Eyes: Yellow Ochre and Terra Cotta.
Bricks: Terra Cotta
Shadow: Dark Brown
Yellow Ochre and True Blue were reflected into the body of the cat.

Conclusion

Here we are at the end of the book already, and I feel like we have barely scratched the surface. There is so much to learn and explore, so many techniques to try.

I have been drawing my whole life, and professionally for more than twenty years and I never tire of it! Every day I wake up eager to draw, I've never missed a day.

When you are doing what your soul cries out to do, that is how it feels. No dread, no feelings of boredom or uncertainty. There is no wondering why you're doing what you're doing. I am so blessed to have this wonderful talent, and I never waste a day without using it.

You have purchased this book because you, too, love to draw, or would like to. I encourage you to just do it! Give it a shot, because you have nothing to lose and potentially a lifetime of enjoyment to gain. Don't be hesitant or afraid of making a mistake. It doesn't matter! Practice is necessary for everything we do. Through practice, we hone our skills and learn our craft.

There is no limit to our capability for learning and possibilities. I will draw until the day I die and will leave still having much left to learn. I have a banner in my studio for my students to read every time they come in. It is a quote I have used for years. For me, it sums up the creative realm. Let it guide you as well.

"There is never a lack of subject matter…just absence of creativity!"
–Lee Hammond

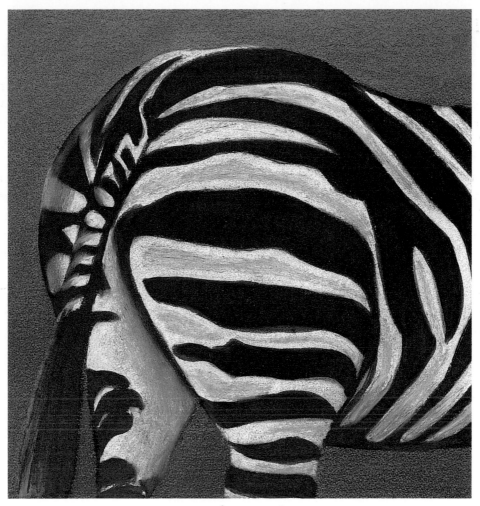

The End

Index